REMEMBERING
# TROY

REMEMBERING

# TROY

HERITAGE ON THE HUDSON

## DON RITTNER

THE
History
PRESS

Published by The History Press
Charleston, SC  29403
www.historypress.net

*Cover Image*: Troy view from Mount Ida. This is a painting by Troy High School art teacher Domenic Delia and was painted in 1964–5. Many of the landmarks in this painting are now gone, victims of urban renewal, fires and careless demolition. *Courtesy of Adriana Delia Collins.*

First published 2008

Manufactured in the United States

ISBN 978.1.59629.536.0

Library of Congress Cataloging-in-Publication Data

Rittner, Don.
Remembering Troy : heritage on the Hudson / Don Rittner.
p. cm.
ISBN 978-1-59629-536-0
1. Troy (N.Y.)--History. 2. Troy (N.Y.)--Biography.  I. Title.
F129.T8R57 2008
974.7'41--dc22
2008030579

*Notice*: The information in this book is true and complete to the best of our knowledge. It is offered without guarantee on the part of the author or The History Press. The author and The History Press disclaim all liability in connection with the use of this book.

*To the Teens of Troy (1965–69).*
*They were great years!*

# CONTENTS

# CONTENTS

# Acknowledgements

I am indebted to many people who have helped me explore Troy's history over the years with documents, lore, photographs and moral support. Thanks to Carl Erickson; the staff at the Rensselaer County Historical Society; John Swanteck; Greta Wagle; Jack, Chris and Kevin Rittner; Lou Ismay; John Wolcott; John Casale; Jim Shaughnessy; Tom Clement; Chris Hunter; Lisa Lewis; Steve, Nick and Charlie at the Famous Lunch for letting me hang out there as a kid; and to Tom Carroll for continuing to put up the good fight. Special thanks go to Jonathan Simcosky, editor at The History Press.

# INTRODUCTION

Troy, New York, is not your average city. It is a city of character and characters. Packed into 221 years of history, Troy has been considered by historians as the birthplace of the American Industrial Revolution, the Silicon Valley of the East and certainly as one of the most innovative and wealthiest cities in nineteenth-century America.

Situated between the Hudson River to the west and the Rensselaer Plateau to the east, Troy stretches along the Hudson River's flood plain and encompasses some 11 square miles of real estate. It is located about 150 miles north of New York City and is the center of government for the county of Rensselaer.

Troy was an iron and collar town—a working-class hero. It made bells, stoves, rails, horseshoes, collars, cuffs and shirts—the latter industry it created. It founded the first science school in the country and educated the majority of the early geologists who explored America. Even during a time when most of the downtown had been destroyed by fire, workers in the southern part of the city were busy building the iron hull plates for the ironclad USS *Monitor* that helped turn the Civil War in favor of the North. It was the home for personalities as diverse as eccentric Boston Corbett (who killed John Wilkes Booth) and "Uncle Sam" Wilson, America's icon, to Emma Willard, who started the first female college. It was a melting pot of ingenuity, personality and productivity during the nineteenth century.

At its peak, Troy had more than seventy-six thousand people living and working here, but like many northeastern cities, the population has dwindled to almost half of that. The industries and personalities that drove them have disappeared and in many instances only photographs remain and give a glimpse of this former glory.

Yet one cannot take away its history, and it is this history that is being retold today because many citizens of Troy have made contributions that are still felt around the country and the world.

For seven years, I had the privilege to write a weekly history column for the *Troy Record*. It allowed me to explore the people and places that made Troy a unique place. I have chosen more than thirty of my favorite columns, have rewritten and updated them and have included illustrations where possible for this volume of *Remembering Troy*.

I belong to the last generation of Trojans who remember the city when it was vibrant and full of people. During the 1960s and '70s, Troy politicians and business leaders felt it necessary to tear down blocks and blocks of commercial and residential neighborhoods to combat the exodus to suburbia. It had disastrous results. Fortunately, in recent years, young professionals and others have rediscovered Troy and are working to make the city vibrant once more.

While the following articles reflect on the past two hundred years of Troy's history, it is my hope that authors will continue to have much to write about Troy two hundred years from now.

I would like to hear your stories and experiences of Troy. You can contact me at drittner@aol.com.

# PART I
# UNIQUE TROJANS

# Burleigh and His Lithographs

During the late nineteenth and early twentieth centuries, a type of map making called "bird's-eye views," or "panoramics," became widely popular in the United States. Often thought of as "balloon" shots, these maps showed a village, city or urban area from an oblique view with individual buildings, streets and landforms in perspective.

These perspectives were not an American invention, though they were used here in pre–Civil War times. They were being used in Europe in the late sixteenth and early seventeenth centuries. In both areas they were often depicted at low angles and were not very detailed. Most of these early forms were small and published in atlases or geography books.

The views of American cities during the Victorian era were more accurate and detailed than earlier ones. Some were even used as promotional gimmicks by real estate agents or chambers of commerce as an enticement for development.

With advances in lithography it became economically feasible to make multiple copies of an "aero" map. This led to the commercial popularity of panoramics since most people could afford to own one and proudly point to their home or business on a map as it hung on their wall. Panoramics continued their popularity right into the 1920s.

Preparing a panoramic map wasn't easy. The artist or artists walked down every street, sketching every building, tree or other features such as hills or streams to present a complete and accurate view as though seen from an elevation up to three thousand feet. American panoramics appeared in state and county atlases, though often the artist was not credited. Most were printed and sold separately either by the individual artist or a publisher.

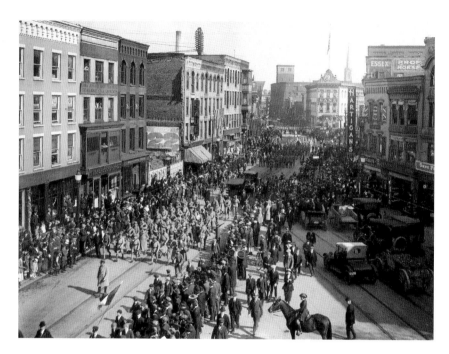

Workers of Burleigh Lithography hang out their windows to watch a parade during World War I. The Burleigh Lithograph Company was located in the Knickerbocker Press building on River Street (second building on left). *Courtesy of the author.*

The Library of Congress has over 1,500 panoramic maps. Five artists are credited with creating more than half of them: Albert Ruger, Thaddeus Mortimer Fowler, Lucien R. Burleigh, Henry Wellge and Oakley H. Bailey.

Our interest is in Lucien P. Burleigh (1853–1923), from Troy.

Burleigh lived in Lansingburgh, but had his office at 361 River Street in Franklin Square. Originally listed as a civil engineer, by 1886 he was promoting himself as a lithographer under the Burleigh Lithographing Company. His most productive years were between 1886 and 1890, but he was still producing as late as 1892.

During the 1880s, Burleigh's views of New York and New England were very popular. The Library of Congress has 163 Burleigh panoramic city plans, although Troy and Lansingburgh are not listed. Burleigh prepared three large lithographs of Lansingburgh, parts of which can be seen in my *Images of America: Lansingburgh* book. Interestingly, a few years back a relative of Burleigh e-mailed me and sent me copies of the Lansingburgh panoramas after reading this story! He still had the original stones.

We are fortunate to obtain a more detailed account of what it was like for Burleigh to produce these lithographs in the old days.

Mal Hormats, eighty-one years young when I interviewed him though now deceased—and a retired air force pilot with his own remarkable history—had given me a great amount of information about the Burleigh establishment. He knew it well since his father, Joseph Hormats, bought the lithographing company ("stones," accounts and equipment) from Burleigh the year he died (1923). Mal worked for his dad for a short time.

According to Mal, who lived in Maryland but grew up on First Street, the Burleigh Lithographing Company occupied the top three stories of 361 River Street, a four-story building. Mal gave me the following account.

The first floor of the Burleigh shop was the business office with many shelves for the boxes of job envelopes. The rear of the floor was one long room that housed a Mergenthaler linotype machine that his dad installed.

Behind this were the type cases where jobs were set up. The walls were shelved to hold reams of all sorts of different paper. An electric motor ran a belt system that drove a small stapling machine; three small hand-fed job presses; and a very large paper cutter.

This floor handled most of the job printing of Burleigh and Hormats. One small stove heated it—burning paper scraps.

The second floor was for stone lithography. At the front was a room used for stone preparation. There was a small flatbed press used to transfer print or drawings to a stone.

Bavarian limestone slabs, 3 inches thick and as large as 3 feet by 3 feet, made up the basic stone. They were very heavy. A full-sized stone, such as one of Burleigh's maps, might weigh two to three hundred pounds. Bavarian limestone weighs about one pound for 12.6 cubic inches. It's used because its density and fine grain allow a high resolution. This is interesting since the Capital District region abounds in limestone but obviously not of the necessary quality.

Stones were ground perfectly flat, as the slightest imperfection would affect the printing process. They were finished off with nitric acid and then covered by a tin wash of gum arabic.

The map was meticulously engraved onto the Bavarian limestone block using wax crayons, pens or brushes.

In back of this first room was the paper drying room. Clamps on the ceiling held paper from the big flatbed press until the ink dried. The walls were lined with thousands of storage areas for printing stones.

Behind the drying room was the big flatbed press, driven by the same belt system as the presses downstairs. The pressman stood on a platform from

which he could feed the large sheets of paper into the press. Each sheet nestled into a preset series of guides that ensured that the paper was exactly aligned. The stone was inked each time by large rollers. Completed sheets were piled in the rear or a small stack was hung up in the drying room.

The old lithography pressmen chewed tobacco. The ink they used in those days had a lot of wax or grease. When it built up too much, the pressman would let fly some spit at the stone. The natural detergent in the tobacco would clear the blurs; then they threw away the sheet with spittle on it and continue the run. (In the same way, many people kept a sack of Bull Durham in their cars to clear their windshields.)

The third floor was mostly stone storage and a small room in which an artist prepared transfers or worked directly on small stones, either using special crayons or etching tools.

Some of Burleigh and Hormats's clients included Cluett and Peabody, Ludlow Valve, Proctors, the City of Troy and countless other Troy industries. Joseph Hormats sold the business in 1968–69 but the new owner moved the location a few doors down and shortly after went out of business. A couple of years later, Franklin Square was demolished.

What happened to all those limestone panoramic plates? Mal's dad gave them to his friends, probably fellow Troy Rotarians, for use as patio blocks!

So, if your dad happened to be a Troy Rotarian, you might want to turn up those large limestone blocks in your backyard or walkway—give me a call if you find one that has etchings!

## LOCAL WOMEN WROTE FROM EXPERIENCE

If you were one of the brave ones who toured the Knickerbocker Mansion during its annual "Knick at Night" Halloween tour in old Schaghticoke, you were given a chance to "meet" some of the past inhabitants of the mansion and surrounding area. Two of the "residents" were Eliza Bleecker and Maria Kittle.

Ann Eliza Bleecker became a successful poet and author during the eighteenth century. Unfortunately, her fame came after she died.

Bleecker was born in 1752 in New York City to Margarette van Wyck and merchant Brandt Schuyler. At a young age, her friends and family would ask her to recite her poetry, which ranged from humorous to sentimental. At the age of seventeen, she married John J. Bleecker and moved to Tomhanick in Rensselaer County. Her life seemed to go downhill after the move.

Not only did the isolation take a toll on her, but in the summer of 1777, during the early part of the American Revolution, the Schaghticoke area was also threatened by approaching British troops of General John Burgoyne. The Bleecker family fled on foot to Albany with their two daughters, infant Abella and six-year-old Margaretta (and perhaps a slave child). Abella didn't make it, dying of dysentery on the way. They joined Bleecker's mother and continued to Red Hook, but the mother also died enroute. To make matters even worse, on their return trip, Caty Swits, Bleecker's sister, also died.

Only four years later, in 1781, a group of British soldiers kidnapped husband John Bleecker. Even though he returned soon, the trauma led to a miscarriage. During her last six years, 1777–83, she suffered from severe depression but was determined to write. Many of her poems and short stories were in the forms of letters to her friends and family.

After her death in 1783, her daughter, Margaretta Faugères, a poet in her own right, published much of her work, which included twenty-three letters, thirty-six poems, *The History of Maria Kittle* (the massacre of Schaghticoke's Kittle family and kidnapping of Maria) and an unfinished short historical novel, *The History of Henry and Ann.* Much of the material appeared in the *New York Magazine* (1790–91) and as a collection called *The Posthumous Works of Ann Eliza Bleecker* in 1793. (You can read these online at http://en.wikisource. org/wiki/The_Posthumous_Works_of_Ann_Eliza_Bleecker.) *Maria Kittle* was republished separately in 1797.

"Indian captivity" writing was popular during this time. While Bleecker's writings were popular, so were Cotton Mather's true accounts of Hanah Dustan's captivity (and revenge) and Mary Rowlandson's 150-mile kidnapping saga. Other true captivity stories were written later by the captors themselves, such as the works of Isaac Webster (1808) and Rachel Plummer (1838).

Lynde Palmer was the pen name for Mary Louise Parmelee from Lansingburgh. She was born on December 10, 1833, and attended Lansingburgh Academy. She later married Augustus Peebles in July 1862 and lived at 534 Third Avenue.

Lynde Palmer apparently began writing children's books after losing her two young children. Palmer wrote many books such as *The Little Captain* (Boston, 1861), *Helps over Hard Places* (1862), *The Good Fight* (1865), *The Honorable Club* (1867), *Drifting and Steering* (Troy, 1867), *One Day's Weaving* (1868), *Archie's Shadow* (1869), *John-Jack* (1870) and *Jeannette's Cisterns* (1882). The last few were part of what was called "The Magnet Stories." Palmer died in 1915.

Finally, Emma Hart Willard (1787–1870) and her sister Almira Hart Lincoln Phelps (1793–1884) wrote textbooks for women. Emma started the

first female college, the Troy Seminary (now Emma Willard). The early life experiences of Emma and Almira no doubt shaped their thinking that women were just as smart as men and they decided to write books with them in mind.

Emma wrote *History of the United States, or Republic of America* (1828); *A System of Universal History in Perspective* (1835); a volume of poetry, *The Fulfillment of a Promise* (1831); *A Treatise on the Motive Powers Which Produce the Circulation of the Blood* (1846); *Guide to the Temple of Time* and *Universal History for Schools* (1849); *Last Leaves of American History* (1849); *Astronography, or Astronomical Geography* (1854); and *Morals for the Young* (1857).

Almira wrote *Familiar Lectures on Botany* (1829), *Dictionary of Chemistry* (1830), *Botany for Beginners* (1833), *Chemistry for Beginners* (1834) and *Familiar Lectures on Chemistry* (1838), as well as the novel *Ida Norman* in 1848. These were followed by *Christian Households* (1858) and *Hours With My Pupils* (1859). At eighty, she wrote her last two books, *Fruits of Autumn* and *Preserved in the Winter of Life*, both published in 1873.

These four women proved that determination will triumph over the most difficult circumstances.

## Paper Boats Made Waters Famous!

Paper is truly a remarkable invention! As early as 4000 BC, ancient Egyptians used papyrus, a type of paper made from a woven mat of reeds and pounded into a hard thin sheet. Ancient Greeks used parchment that was made from animal skins. But paper as we know it today was invented in China in AD 105. Historical records show that its invention was reported that year to the Chinese emperor by Ts'ai Lun, an official of the Imperial Court. Although recent archaeology has pushed the date back two hundred years, the fact is that paper has been around for a very long time.

While we all use paper for communication (and occasionally for making paper airplanes), there were many other uses put to the product when it was first introduced to America in the eighteenth century. Paper has been used for making clothes, train car wheels, observatory domes, coffins and even boats! Yes, boats, and that of course bring us to Troy.

Eliza Waters (formerly a druggist) and his son opened a factory at 303 River Street and began making paper boxes. According to historians, that all changed when George Waters, the teenage son of Eliza, was invited to a masquerade party in 1867. Instead of paying eight dollars for a mask, he borrowed the mask and made a replica of it using paper and paste from his father's factory.

THE ARCTIC VARIETY (KAYAK)

THE IMPROVED TYPE (MARIA THERESA CANOE).

The paper boat *Maria Theresa*, used by Nathaniel Holmes Bishop in his voyage and subsequent book, *Voyage of the Paper Canoe in 1874*. This paper boat is now in the Smithsonian.

Impressed with his success, he attempted to fix a leaky cedar rowing shell that he picked up by varnishing and gluing paper to portions of the hull. It was this success that led him and his father in June of that year to build the world's first paper boat. By using the hull of a wooden rowing shell as the mold, they glued strips of paper in unbroken lengths from stem to stern and varnished them together. This first paper boat was christened *The Experiment.*

Only one year after the first Waters paper boat was constructed, in 1868, paper racing hulls won fourteen water races followed by twenty-six wins the following year, making quite a splash with the rowing public.

In 1871, Waters issued a four-hundred-plus-page "Catalogue and Oarsman's Manual." By 1875, they were producing more than forty-five different racing shells, rowboats or canoes and the *New York Daily Graphic* declared that they had the largest boat factory in the United States. That same year, a Cornell crew rowing a paper six-oared boat beat ten other colleges in wooden boats at Saratoga Lake, and the following year, paper boats swept all events in the Centennial Regatta.

Waters paper boats were not only used for racing. Pleasure canoes were also made and two people helped make the Waters name famous. A reporter, Julius J. Chambers, planned a trip from the headwaters of the Mississippi to its mouth in New Orleans. In May of 1872, he began his voyage at the White Earth Indian Reservation in central Minnesota with his paper boat. A month later, he made it to Lake Itasca and explored the tributaries feeding the lake

but terminated his trip just short of his final destination. He penned reports of the trip in the *New York Herald*.

Another adventurer, Nathaniel Holmes Bishop, began a trip from Quebec to the gulf coast of Florida in 1874 using a conventional wooden canoe. When he reached Troy in his wooden canoe, he discovered the Waters paper boat factory, ordered one and abandoned his wooden one *and* his assistant. Liberated from both, he eventually made it south. He wrote a popular book of his exploits called the *Voyage of the Paper Canoe* detailing his trip and his paper boat, and it was quite a hit with the public.

Fast and light, Waters paper boats would be dominant for thirty years. However, the Waters family didn't rest on their laurels. In 1878, they built a paper observatory dome twenty-nine feet in diameter for the newly erected Proudfit Observatory at Rensselaer Polytechnic Institute (RPI). Using the same construction techniques that were used to make their boats, thick linen paper was placed over dome molds. The sixteen individually cast sections were then bolted together, forming the two-ton observatory dome. It was removed twenty years later when the building was remodeled in 1889. They continued making domes around the country, including one thirty feet in diameter for the U.S. Academy at West Point.

The paper boat industry, literally, was born and died with the founders. George and Eliza died in 1902 and 1904, respectively, shortly after George accidentally burned their factory down in 1901.

Only three surviving Waters paper boats are known to exist. You don't have to travel far to see one now on display at the Rensselaer County Historical Society.

The paper boat industry was a short-lived industry but it is another example of the entrepreneurial spirit that was so pervasive during Troy's industrial heyday.

## RESTORING TROY A FAMILY AFFAIR

When I first met Troy native Carl Erickson in 1974, we were both carrying placards protesting the Troy Savings Bank's proposal to demolish 50 Second Street. The bank wanted to add a couple of parking spaces to their existing lot. RPI Professor Bill Brower didn't think it wise and organized what was probably Troy's first real protest over historic preservation. We won!

I've considered Carl a friend ever since and have been amazed at how dedicated he is to Troy. Carl exemplifies what early settlers of this city had—a lot of guts and perseverance.

Carl was born here to Carl Erickson Sr. and the former Marion Kittell. Carl's dad has been there shoulder to shoulder while Carl pursued his passion of single-handily restoring some seven historic buildings in this city.

I'm not talking about someone looking for government handouts, or taking shortcuts in a quick rehab. Carl and his dad have painstakingly restored some of Troy's finest architectural gems and there seems to be no slowing down either.

As a boy, Carl went to School 16 and Troy High and then off to Brooklyn to study at the Pratt Institute for industrial design. Like many of his generation, Carl joined the Peace Corps. He was sent to South America, where he worked in Colombia with a company that made and exported handcrafts. He finally left in 1967 and was drafted, ending up in Korea in 1970.

While in the military, his mom sent a *Record* newspaper clipping about the RCCA purchasing a building along Washington Park. He was so impressed with the possibilities that he wrote a letter to the editor expressing his views that it was the start of bringing back the park.

After his military stint, Carl moved back to Troy and found a job at the New York State Museum as an exhibit designer, retiring only a few years ago.

When I first met Carl, he had already purchased his first project two years earlier at 116 Third Street, a three-story 1880s-era brick house. Prophetically, Carl's boss, after hearing of his purchase and desire to rehab the building, told Carl it was a good idea, stating, "It was all coming back," referring to Troy's revival. One could say that Carl may have been the first to start the revival ball rolling.

I was the city archaeologist for Albany then but at least two or three times a week I would stop in to see how Carl was progressing on his project. Always cheerful and accommodating, he and I would take a coffee break at the Jack in the Box, and if we weren't discussing how to solve the world's problems, the discussion would turn to the house.

After its completion, Carl went on to restore the 1835 Elias Ross House at 110 Third Street, the facade on an 1830s row house at 112 First Street, followed by an 1895 Queen Anne–style at 114 Washington Street. These were followed by the 1828 Federal-era Colley House at 112 Third, and then he tackled 180 Fourth Street, an 1820s Federal wooden structure known as the "Pumpkin House."

Located in an area of Troy with homes and businesses of some of the town's early nineteenth-century potters, this restoration acted like a lightning rod. The Pumpkin House was placed on the National Register of Historic Places in 2000. Shortly after, others like John Pattison began purchasing other potters' homes and began restoring them, creating a community now known as the Pottery District.

Instead of resting on his laurels, Carl continued his passion by purchasing the Townsend McCoun House at Twelve State Street. For the past year, he and his dad, now ninety-one, have been bringing this Federal-era building back to

life. This house originally stood at the northwest corner of Second and State Streets but was picked up and moved to the present location when the Caldwell Apartments were built in 1907.

Part of Carl's passion for Troy certainly must be attributed to his dad, who always has had a positive outlook about the future of Troy. Carl continues to serve Troy as a member of the city's historic district advisory commission, which is responsible for ensuring the integrity of Troy's local historic districts. A few years ago, he came up with the "Watt's Up" project, a program to illuminate Troy's architectural jewels. He has been an integral part of the Barker Park restoration project and his new idea concerns the Plaza at Monument Square, an outdoor café where people can meet and network.

Carl is absolutely convinced that the past is our future. I'm convinced that the future of our past would have been lost without Carl showing all of us that preserving our historic buildings can be an individual journey well rewarded. Carl holds "court" every week at the farmer's market and is always looking for the next house to restore.

## THE ECCENTRIC TROJAN

On the evening of Good Friday, April 14, 1865, actor and Confederate sympathizer John Wilkes Booth assassinated President Lincoln with a single shot to the back of the head.

Few know that the person who killed Booth for his deed was an eccentric former hat maker from Troy, Thomas P. Corbett. Corbett was born in England in 1832 and came to New York with his family in 1839, finally settling in Troy where he became a hatter.

Mercury compounds were commonly used in felt hat making to kill bacteria and prevent rotting. Hatters developed the "shakes" and became unstable by breathing in mercury fumes and getting it on their hands, hence the phrase "Mad as a Hatter." Symptoms of chronic mercury exposure on the nervous system include increased excitability, attention/concentration deficits, mental instability, tendency to weep, fine tremors of the hands and feet, depression, hallucinations and other personality changes. Most writers attribute Corbett's later bizarre personality to having Mad Hatter's disease.

Corbett married but his wife died in childbirth. He moved to Albany, Boston, Richmond and finally to New York City, where he enlisted in the New York State militia. While in Boston, he changed his name to "Boston," after being converted to Methodism. Trying to imitate Jesus, he grew his hair very long, and in order to

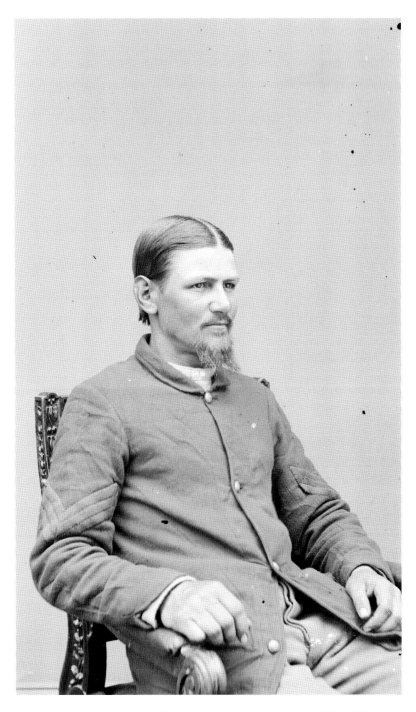

Portrait of Boston Corbett of Troy, who killed Lincoln's assassin, John Wilkes Booth, in a barn on April 26, 1865. *Courtesy of the Library of Congress.*

avoid the temptation of prostitutes, took a pair of scissors and castrated himself on July 16, 1858. Corbett's zealous, religious behavior landed him in trouble many times when he would brandish his revolver, sometimes discharging it at people who blasphemed the Lord in his eyes.

Corbett showed remarkable marksmanship and bravery and reenlisted three times during the Civil War. He was with a detachment of the Sixteenth New York when surrounded by the famous "Gray Ghost," Confederate Colonel John Singleton Mosby. All surrendered except Corbett, who stood out and fired all of his bullets from a pistol and rifle before he finally was forced to surrender. In admiration of his bravery, Mosby ordered his men not to kill Corbett. While at Andersonville prison, Corbett tried to escape but was caught. Of the fourteen prisoners from the detachment, only Corbett and one other survived the imprisonment.

Corbett later became a sergeant and was one of the twenty-six cavalrymen selected from the Sixteenth New York Regiment on April 24, 1865, to pursue Booth after Lincoln's assassination. On April 26, they cornered Booth and accomplice David Herold in a tobacco barn on the Virginia farm of Richard Garrett. The directive from command was: "Don't shoot Booth, but take him alive."

The barn was set on fire and Herold surrendered, but Booth remained inside. According to Lieutenant Edward P. Doherty, Corbett "asked permission to enter the barn alone, which I refused." Instead, Corbett went around to the back of the barn. When he saw Booth through a crack in the barn, he took out his Colt revolver and from a distance of a few yards shot Booth "on the back of his head, very nearly in the same part where his own ball had struck the President," according to Brigadier General Henry L. Burnett. Booth was paralyzed and died a few hours later. Corbett disobeyed orders, proclaiming, "God Almighty directed me," and was arrested and thrown into the brig. Charges were dropped by Secretary of War Edwin Stanton, proclaiming, "The rebel is dead. The patriot lives." Corbett received his share of the reward money ($1,653.85). In his official statement of May 1, 1865, Corbett claimed he shot Booth because he thought he was getting ready to use his weapons.

Corbett returned to hat making but then moved to Concordia, Kansas, in 1878, where he lived in a self-made dirt dugout a few miles out of town. A historical marker denotes his dugout (now merely a depression). He gave sermons to local churches, but brought his gun out when he felt someone wasn't obeying the Lord's wishes. There are many published examples of his eccentric behavior. In 1887, he was appointed assistant doorkeeper of the Kansas House of Representatives in Topeka, but on Tuesday, February 15, after overhearing

a conversation in which the legislature's opening prayer was being mocked, he jumped up, whipped out his revolver and waved or discharged his gun. No one was injured, but he was arrested, declared insane and sent to the Topeka Asylum for the Insane. On May 26, 1888, he jumped on a horse left at the entrance to the asylum's grounds and escaped to Neodesha, Kansas, to meet Richard Thatcher, the other survivor of the Andersonville prison. Stating that he was headed for Mexico, Corbett instructed Thatcher to return the horse to its rightful owner. Some stories say he ended up a medicine salesman, or died in the 1894 Great Hinckley (Minnesota) Forest Fire. Corbett was never seen again. Four of the eight captured Booth accomplices were hung, including the first woman ever executed by the federal government.

## Trojans Rose to the Occasion

I remember being amazed while watching drone aircraft being flown over Afghanistan during the war against terrorism. Not only did they visually monitor the landscape for miles, but also delivered surprise payloads on unsuspecting terrorists. Fellow Troy lover Jim Shepard pointed out to me that, not surprisingly, the advent of military reconnaissance had a Troy hand in it.

John LaMountain was born in Canada in 1830 but moved to Lansingburgh in 1858 with his brothers, Charles and Edward, and his wife, Mary. While it isn't known when LaMountain developed an interest in ballooning, he did go up that year and got due publicity in the *Troy Times*.

LaMountain had high ambitions and in 1858 built a larger balloon, the *Atlantic*, for crossing the Atlantic Ocean. Over sixty feet in diameter and constructed with Chinese silk, it had a wicker basket for the crew; below that it had a lifeboat with propellers. Teaming up his mentor, financer Oliver A. Gager and Vermont potter John Wise (already a veteran of air ascents since 1835), LaMountain was ready to fly. On July 1, his team, along with a newspaper reporter, left St. Louis on a test run to the east. They traveled 1,150 miles in some twenty hours at 57 miles per hour, eventually crashing into a tree in Jefferson County, New York. It was publicized as the greatest aerial voyage in history. It set an official world distance record for nonstop air flight that would not be broken until 1910, and it was the first airmail delivery, as Wise literally "dropped" off a bag of mail consigned by the U.S. Express Company.

LaMountain ditched his team and tried again in September in Watertown with another reporter, but hit fast winds at one hundred miles per hour. They ended up in the Canadian wilderness and went a week without food, finally being

rescued by a lumber party. LaMountain took a break and built some smaller balloons at his factory in the Burgh. He attempted an ascent at the Washington County Fair in 1860, but due to high winds and lack of suitable gas, he couldn't get up after several attempts. He and his balloon barely got out of the fairgrounds alive and in one piece. Not good to get farmers in that area mad at you.

Because of his associations with newspapermen, he developed a national reputation for his exploits. At the outbreak of the Civil War, LaMountain thought that he could engage his balloons to spy on Confederate locations. He wrote directly to the secretary of war, outlining his plan to observe enemy troops from the air and had endorsements from many local Troy bigwigs, but he was ignored. LaMountain had competition in the form of T.S.C. Lowe, another famous aeronaut, who was attempting the same thing. Lowe had the political connections and met Lincoln with his airship, the *Enterprise*. On June 17, 1861, Lowe demonstrated the first telegraphic transmission from the air. At five hundred feet high, he was rigged with telegraph wire from the American Telegraph Company and the cables and equipment on the ship were attached to the ground.

LaMountain was given a chance, however, to prove his stuff by Major General Benjamin F. Butler, in command of Union forces at Fort Monroe, Virginia. LaMountain beat Lowe to the punch in July 1861, when he made two successful ascensions at Fort Monroe—going up to three thousand feet, finding a Confederate encampment about three miles beyond and a large force on the James River eight miles above Newport News. He also noticed cannon positions. LaMountain became the first to successfully use a balloon in military service. However, Lincoln gave Lowe control of his newly formed Balloon Corps, a civilian group. Ironically, a year later, another Trojan, General John Wool, and the Troy-built ironclad *Monitor*, would turn the war in favor of the Union at the same location.

Both LaMountain and Lowe introduced the use of aircraft carriers. Lowe directed the construction in 1861 of the first aircraft carrier, the *George Washington Parke Custis*, a rebuilt coal barge. On August 3, 1861, LaMountain used the deck of a small vessel, *Fanny*, over the James River, and the Union tugboat *Adriatic*, for the same purpose.

Hostilities arose between LaMountain and Lowe and on February 19, 1862, General McClellan dismissed LaMountain from service. Lowe was forced to resign on May 8, 1863, accused of financial impropriety. The Balloon Corps was abandoned by August 1863.

When LaMountain came back to Troy, he lost his wife and daughter. In 1864, he married his cousin and was divorced by 1866. He moved to South Bend, Indiana, where he died at the age of forty on February 14, 1870.

# TROY CARPENTER FOUNDED KINGSTON

Thomas Chambers was a man who liked to be first. He was the first European to settle in Troy and perhaps the first to settle Kingston, New York.

Chambers, an English carpenter, introduced to the colonies the idea of covering houses with clapboards. His nickname was "the Clabbort" (clapboard). He first appears in New Netherland records on May 6, 1642, in a contract to build a house and cover it with five hundred clapboards for Jan Jansen Schepmoes at Fort Amsterdam (New York City).

Chambers settled in Troy on September 7, 1646. He signed a five-year lease with the officers of Rensselaerwyck and rented land between the Wynantskill and Poestenkill. He built his own house and barn, but received two mares, two stallions and four cows as part of the arrangement. He also had first rights to erect a sawmill on either the Wynantskill or Poestenkill land. He occupied the land from 1647 to July 14, 1654, when he moved to the Esopus area (Kingston). Apparently Chambers didn't like the political and economic restrictions placed on him under the Rensselaerwyck manor system and ended up leading a movement toward independent farming and freehold land ownership in the Esopus area.

On June 5, 1652, two Esopus Indians sold Chambers a parcel of land on Esopus Creek. Some sixty or seventy Dutch immigrants and friends of Chambers became permanent settlers within a year. Esopus was changed to Wildwyck ("wild woods") or Wiltwyck by Peter Stuyvesant in 1661. Chambers, in the meantime, was appointed captain of the citizen's militia in April 1662.

War broke out between the settlers and natives in the Esopus area. Esopus Indians were not happy about trade dealings and the fact that their people were being sold as slaves. In 1658, following the first war, Governor Stuyvesant personally ordered settlers to move in closer and build fortifications and a stockade. It was in 1663 that Wildwyck (Kingston) and a nearby village (Hurley) were attacked by the natives in broad daylight.

Chambers was wounded on his way into the village but ordered the townsmen to secure the gates and bring out a cannon. It appears the cannon did the job to save the village. On October 7, 1665, a treaty was signed between the Esopus Indians and Governor Nicolls.

Chambers became a commissary (council member) in 1665 and was highly regarded by Nicolls and later governors, and he held public office almost continuously from the time of the English conquest. In 1670, Chambers became a justice of the peace and resigned from the commissary position, not wanting to have a conflict of interest.

After the second Esopus war, Chambers built a large stone mansion (Foxhall) on his land a mile northeast of the Kingston stockade. In 1672, it was made into a "manor" by Governor Lovelace. In October 1681, Chambers bought a parcel on the Strand (beach on the Roundout Creek), and on October 28, 1686, he was issued a new patent by Governor Thomas Dongan, adding another three hundred acres.

Chambers had no children of his own but married twice. His first wife, Margriet, was the widow of Mattys Jansen (van Keulen) of Fort Orange (Albany). In 1681, he married Laurent Kellenaer, widow of Domine Laurentius Van Gaasbeeck. In his will, he instructed that his estate and possessions were to be given on the condition that his heirs always use the surname Chambers.

Chambers died on April 8, 1694, and was buried near his house on the Strand. Jansen Hasbrouck erected a brick house on the site in 1850, and Chambers's vault was removed to Montrepose Cemetery and buried in the ground. In the vault with Chambers and his wife Laurentia was Abraham Gaasbeeck Chambers, Abraham's wife and a number of their children and grandchildren. Above the ground, the vault was identified only by a plain, unmarked bluestone slab. A granite monument in front of the vault was dedicated on October 4, 1909.

In the rear of the Hasbrouch House stood a large, old pear tree that was planted by Chambers and stood until 1926. A small section of the trunk and sample of the fruit are preserved today. In the foundation of the north side of the house on the northeast corner was embedded Chambers's original tombstone, bearing his initial and the date of his death. In the summer of 1960, the stone was removed from the foundation and the house was demolished.

Chambers spent over forty years in the Kingston area, making numerous contributions as a citizen and public official. How Troy would be different if he had stayed here is conjecture, but no doubt he would have made contributions. He was a proven leader.

## Troy's Contribution to the Wild West

William Henry Jackson is well known as one of the most respected landscape photographers of the American West. Jackson took more than fifty thousand photographs of the West between the years 1880 and 1920. He also found time to write and publish more than fifty books, articles, albums and manuscripts, and his autobiography.

Born on April 4, 1853, in the Adirondack village of Keeseville, New York, he was only four years old when the announcement of the discovery of photography was made.

His early interest in photography came from his father, George Hallock Jackson, a blacksmith in Keeseville and the first to buy a camera. After losing interest in the new medium, he gave it to his young son. His mother Harriet was a painter and instilled in young William an appreciation for art. In 1844, the family moved to Georgia and moved to Troy nine years later. His father became a wagon maker at Seven Fulton Street.

While a teen in Troy, young Jackson took his drawing talent and designed display cards for a local pharmacy and other stores, and painted landscapes on screens. He was hired in 1858 by the ambrotypist (early photographer) Christopher C. Schoonmaker (282 River Street) as a retouching artist. Here he learned his craft until he landed another job in Rutland, Vermont, with the photographer Frank Mowry, for whom he also retouched photographs and learned to tint them in full color; from Mowry he learned the entire photographic process.

Jackson cut his career short in 1862 to join the Twelfth Vermont Infantry during the Civil War but resumed tinting and creating original oil paintings after the war. He was hired for twenty-five dollars a week by the leading photographer of Burlington, Vermont, but left Vermont after breaking up with his fiancée.

He moved to New York City in 1866, but soon headed west with a Civil War buddy, Ruel Rounds, finally landing in Omaha, Nebraska, where he became an assistant in Hamilton's Gallery, which he later purchased along with another. After inviting his brother to join him, they combined the two studios into one company—Jackson Brothers Photographers. It was the same time that he began photographing the first images of the Pawnee, Otoe, Omaha, Winnebago, Ponca and Osage Indian tribes. Some three thousand glass plate negatives of these were given later to the Smithsonian Institute.

Jackson married Mollie Greer in Omaha on May 10, 1869, and six days later left for Cheyenne to begin photographing. He was commissioned in 1869 by the E. & H.T. Anthony & Company to supply them with ten thousand stereoviews of the American West. The following year, he joined Ferdinand Vandiveer Hayden, head of the U.S. Geological Survey, as official photographer and stayed with him until 1878. During this period, he photographed for the first time the Old Oregon Trail, Yellowstone, Mammoth Hot Springs, Tower Falls, the Rocky Mountains and Mesa Verde, to name a few.

It has been written that because of his images of Yellowstone, Congress established that Yellowstone should be set aside forever as a national park. President Grant signed it into law on March 1, 1872. Jackson continued for the next few years, traveling and photographing and compiling a tremendous set of images, including thirty thousand negatives of just railroads.

In 1883, he became his own corporation, the W.H. Jackson Photograph and Publishing Company, Incorporated, and published several volumes of images of Mexico and Colorado. While traveling with the World's Transportation Commission to the Near and Far East and other parts of the world from 1894 to 1896, he was known as the "Great American Ambassador." In 1897, he was offered a job with the Detroit Publishing Company, a well-known publisher of stereoviews and postcards. He became a major stockholder and chief photographer of the company and was instrumental in bringing the Swiss-invented Photochrom process (an elaborate way to print color on postcards) to America. The Detroit firm was the only American company to license the process. However, by 1903, Jackson put his camera away to become supervisor of more than forty people until the company experienced financial difficulties in 1924.

He relocated to Washington, D.C., and later New York City to become the research secretary for the Oregon Trail Memorial Association, and was later hired by the Roosevelt administration to paint murals of several surveys of the 1870s–80s. He continued producing paintings and selling his negatives and even acted as a technical advisor in the filming of the classic movie *Gone with the Wind*. He died from complications of a fall on June 30, 1942, at the age of ninety-nine. His work, which includes photographs, watercolors, oils and sketches, continues to be revered today.

## Troy's Hart Sisters

Emma Hart Willard and Almira Hart Lincoln Phelps are two names that are associated with Troy, but are admired in education circles throughout the country.

In 1807, Emma Hart (1787–1870), a young Connecticut woman, and the next-to-last of seventeen children, began her lifelong work to bring women equal access to education. This was a time in history when women were not allowed in college, but rather were confined to female academies that specialized in classes "suitable" for girls.

Her success in teaching in Connecticut prompted her to write "An Address to the Public; Particularly to the Members of the Legislature of New-York, Proposing a Plan for Improving Female Education" in 1819. The New York State legislature didn't do anything (some members thought she was crazy), but the pamphlet was noticed by Thomas Jefferson and John Adams.

Also impressed was Governor DeWitt Clinton, who invited Willard (Hart married physician John Willard in 1809) to open a school in the state of

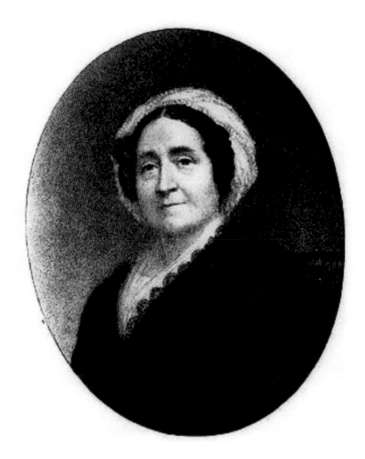

Almira Phelps.

New York. In 1819, she opened a school in Waterford. However, several of Troy's visionaries convinced the city fathers to raise $4,000 in taxes to begin construction of a school for Willard. They purchased the old Coffee House next to the village green between Second, First and Congress Streets and began renovations. Willard and company moved into the "Troy Female Seminary" in 1821, which today continues its mission in Troy, 187 years strong.

According to one history, the seminary was the first such school, predating the first public high schools for girls in Boston and New York City by five years and the famous Mary Lyon's Mount Holyoke Seminary by sixteen years. It was a pioneer in the teaching of science, mathematics and social studies and the school attracted students from wealthy families. By 1831, there was

an enrollment of over three hundred students, with more than one hundred boarding there.

However, one of the biggest problems in female education was finding textbooks. All textbooks at the time were written for men. So, Emma wrote some of the school's textbooks: *History of the United States, or Republic of America* (1828) and *A System of Universal History in Perspective* (1835), as well as a volume of poetry, *The Fulfillment of a Promise* (1831).

Emma headed the college until 1838, by then shaping the futures of hundreds of women. She continued to lecture and write books, including *A Treatise on the Motive Powers Which Produce the Circulation of the Blood* (1846); *Guide to the Temple of Time* and *Universal History for Schools* (1849); *Last Leaves of American History* (1849); *Astronography; or Astronomical Geography* (1854); and *Morals for the Young* (1857). She died in Troy in 1870, and the school was renamed for her in 1895. It was moved to its present location in the east side of the city in 1910.

Emma's youngest sister, Almira Hart, also made an impact on female education. She followed in Emma's footsteps in her formative years, teaching at Berlin Academy; in 1817, she married Simeon Lincoln, editor of the *Connecticut Mirror* of Hartford. His death only six years later brought Almira to Troy to teach in her sister's Troy Female Seminary. She stayed for eight years, teaching and serving as principal.

While she was in Troy, two people had a great influence on Almira—her sister Emma, and Amos Eaton, the founder of RPI and the father of American geology. Eaton introduced her to a new method of teaching called the Pestalozzi method, based on a Swiss education reformer (Johann Heinrich Pestalozzi, 1746–1827) who advocated educating the poor, emphasizing two teaching methods—instructors should start with simple beginnings and proceed to the complicated, and should have a "hands-on" lecture. Most of these principles are now used in modern elementary education.

Almira implemented both methods in her classrooms in Troy. During the eight years Almira was at the seminary, she began writing textbooks, like her sister, on botany, natural philosophy (physics), geology and, specifically, chemistry. Some of her popular works included *Familiar Lectures on Botany* (1829), *Dictionary of Chemistry* (1830), *Botany for Beginners* (1833), *Chemistry for Beginners* (1834) and *Familiar Lectures on Chemistry* (1838). Her textbooks were popular and used throughout the United States. In 1859, Almira was the second woman ever elected into the American Association for the Advancement of Science.

In 1831, she married Judge John Phelps to become Almira Hart Lincoln Phelps. Almira penned a novel, *Ida Norman*, in 1848. In 1856, she retired to Baltimore but continued writing for national publications and authored more

books: *Christian Households* (1858) and *Hours With My Pupils* (1859). At eighty, she wrote her last two books, *Fruits of Autumn* and *Preserved in the Winter of Life*, both published in 1873. She died in July 1884.

To this day, both Emma and Almira Hart's lasting influence on the education of women is felt around the world.

# TROY'S MR. PHELPS

When John Casale was a kid, his father, who worked for the D&H Railroad, brought home some old telegraph equipment for him to experiment on. This piqued his interest, and at age fifteen, John received his ham radio license. It's not surprising that today he's a communications expert for Niagara Mohawk (National Grid), and that he would discover and bring to light one of Troy's forgotten inventors, George M. Phelps. The Smithsonian says that Phelps "developed what became the standard printing telegraph in American offices." Locally, most citizens have never heard of him.

According to Casale, Phelps invented and improved printing telegraph systems, set design standards for many telegraph instruments, invented stock tickers and telephone instruments and built the patent models for some of Edison's early inventions.

Phelps became an apprentice machinist working for his uncle Jonas H. Phelps in Troy as a mathematical instrument maker. Jonas Phelps, with William Gurley, became one of the leading makers of high-quality surveying instruments (now Gurley Precision Instruments).

Nephew George worked for them as a machinist learning the trade, and in 1850, at age thirty, set up his first shop on the corner of First and Adams Streets, working on light machinery, paper-sorting machines and safe locks.

During the 1840s, Phelps followed the evolution of the telegraph. In 1845, the Albany & Buffalo Telegraph Company built a line from New York City to Buffalo. Ezra Cornell erected a portion of it between New York City and Albany. Two years later, Cornell erected a telegraph line from Troy through Vermont to Montreal, under contract with the Troy & Canada Junction Telegraph Company. During those days, telegraph companies came and went, and by 1852 the telegraph industry was highly competitive between companies using conventional Morse technology and those using printing telegraph systems.

According to research by Casale, the expansion and growth caused by this competition created a shortage of instruments and of skilled workmen to make them. Phelps was hired to build a printing telegraph that would be

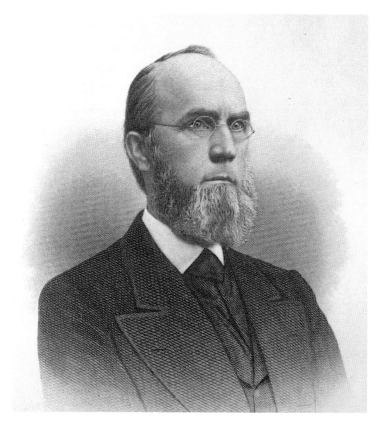

Troy inventor George M. Phelps, 1879. *Courtesy of John Casale.*

used throughout the United States based on the design of Royal E. House. It was efficient for its day (transmitting up to forty words per minute), but very complicated. Phelps teamed up with Jarius Dickerman, who funded Phelps and his "House's Printing Telegraph Instrument Manufacturer," at 41 Ferry Street. Phelps built these for at least four years and his reputation as a man who could solve problems quickly spread.

In 1855, a young Kentucky music teacher, David E. Hughes, accidentally came up with a design for a new type of printing telegraph. The printer had some shortcomings but a new company, the American Telegraph Company (ATC), purchased the North American rights and they gave it to Phelps to tackle. He made two improvements and it was quickly placed into service on some of ATC's lines, where it proved successful. A year later, ATC purchased the Phelps and Dickerman factory in Troy and George became superintendent.

He continued working on improvements for printing telegraphs and, by 1859, his work eventually evolved into one of his most notable inventions, the Phelps Combination Printer or American Combination Printer. He took certain features of the House and Hughes printer and added his own improvements. It became recognized as the most successful type-printing telegraph in the world.

In 1861, ATC made Phelps superintendent of their largest factory in Brooklyn and purchased the rights to his more important patents. After the Civil War, ATC, along with Phelps, was acquired by Western Union. In addition to being the superintendent of Western Union's New York factory, he also became their chief machinist.

In 1870, he designed a stock ticker that helped Western Union force a merger of the Gold and Stock Telegraph Company. In 1875, he introduced the last in his series of large, fast, printing telegraph machines. He built what is his most significant achievement in printing telegraphy, called the Phelps Electro-Motor Telegraph, achieving speeds of up to sixty words per minute. Western Union and Thomas Edison eventually worked together with Phelps, designing and building some of Edison's inventions that helped improve telegraphy and even worked on some of his early telephone designs.

In 1877, two million New York City residents set their timepieces to a daily noontime event that occurred on top of Western Union's headquarters at 195 Broadway (then the tallest building). A ball was dropped precisely at noon, triggered via telegraph by an operator at the National Observatory in Washington. This system, including ball and discharging apparatus, was designed and built by Phelps. The Time Ball stayed in use until 1913, when its view became obstructed by New York's growing skyline.

Phelps died in 1888 and was buried at Oakwood Cemetery. In 1999, John Casale "adopted" his gravesite. He's maintained it ever since and in 2001 added a bronze plaque inscribed with a quote from the Smithsonian.

One Trojan looking after another!

# TROY'S UNCLE SAM

Ok, there's no Santa Claus, nor an Easter Bunny, but there is one cultural icon that is real—Uncle Sam. Fortunately for Troy, it was a popular businessman who became the symbol of a new emerging nation. The alternative could have been: "Home of Brother Jonathan."

Inhabitants of the new country and Europeans knew America as "Brother Jonathan" for several years. Brother Jonathan appeared after the Revolution and

The second home of "Uncle Sam" Wilson was on the corner of Seventh Avenue and Ferry Street. The original house was composed of the two top floors. The bottom floor was added when Ferry Street was graded sometime in the late nineteenth or early twentieth century. *Courtesy of the Rensselaer County Historical Society.*

seems to be based on Jonathan Trumball, governor of Connecticut. George Washington relied on him for supplies and advice during the war, and would utter, "We must consult Brother Jonathan on the subject" when contemplating actions.

The English used the term as an insult (as they did Yankee Doodle), in friendship or tongue-in-cheek, and it came to symbolize the typical American to many overseas. Brother Jonathan became a sympathetic figure for early Americans after the war and appeared in a Boston play in 1787 called *The Contrast*. The name even appeared in music and cartoons of the period, often showing him whittling, a favorite pastime of his. However, it was the War of 1812 that changed the course of this American ethnoglyph.

In February 1789, brothers Samuel and Ebenezer Wilson trudged on foot to the new village of Vanderheyden (later renamed Troy). Born in Massachusetts but raised in Mason, New Hampshire, the kids knew how to make bricks.

The Wilson brothers started brick making at the west foot of Mount Ida at Sixth Avenue and Ferry Street. In 1793, they leased a lot from Jacob D. Vanderheyden on the northeast corner of Second and Ferry Streets and

built a small house. They also created a butchery and built a large slaughter- and packinghouse on the north bank of the Poestenkill. With more than one hundred men working for them, they slaughtered more than a thousand head of cattle a week.

Just south of Troy in Greenbush, the U.S. government purchased three hundred acres and built barracks and a parade ground to house some six thousand troops. It wasn't uncommon for troops to pass through Troy on their way to the camp and this included Troy's own "Fusileers," "Trojan Greens" and "Troy Invincibles." Here they would recuperate and eat. Large oak casks of salted beef and pork with the initials *U.S.* were a common sight.

Sam Wilson was known to his friends and family around Troy as "Uncle Sam." Apparently, he possessed a very kind disposition. Sam and Ebenezer advertised as early as 1805 that they could butcher and pack 150 head of cattle a day. When the War of 1812 broke out, Sam secured a job as meat inspector for the Northern army and also sought contracts to supply meat.

One of the accounts Wilson inspected was for Elbert Anderson. Anderson had secured a contract for a year to supply all rations to troops in New York and New Jersey. In October 1812, he advertised for bids to supply two thousand barrels of pork and three thousand barrels of beef, to be packed in barrels of white oak. The Wilsons got the job. The barrels were then marked *E.A.-U.S.*, referring to Anderson and the United States. When asked what the initials meant, a Wilson workman said it referred to Elbert Anderson and "Uncle Sam."

The name Uncle Sam caught on since everyone in the area knew "Uncle Sam" Wilson (and wife "Aunt Betsey"). In 1813, a broadside was printed with the first reference to Uncle Sam, and mention is made the same year in the Troy *Post*. Many periodicals carried the notion of Uncle Sam the following year and it simply caught on. While it began as a local regional folk tale, it soon caught on nationally. Today, United States (U.S.) and Uncle Sam are one in the same.

Sam Wilson had a farmhouse at the junction of Cottage and Fifteenth Streets, and just north of Liberty and Division Streets (at the end of Mount Ida) the area was called Wilson's Hollow. Later, he built a farm house at 177 Ferry and Seventh Streets. He died there on July 31, 1854.

I remember this house, since I lived opposite it as a teenager. Ironically, it was demolished during the American Bicentennial, but I can't remember if it was the city or state that demolished it.

Former City Manager Steve Dworksy tells a great story about the episode. The actor E.G. Marshall was filming various "Bicentennial Minutes," that appeared on

TV in 1976. As the story goes, Marshall's people called and asked for permission to shoot a Bicentennial Minute at Uncle Sam's house. I guess someone forgot to mention that the house was just demolished. When taken to the site, Marshall, irritated but the consummate actor, looked around, found a brick and held it up, ad-libbing the "newly scripted" Bicentennial Minute.

A few years ago, a fellow who had collected Uncle Sam memorabilia for some forty years offered his collection to the city for an Uncle Sam museum. The city would not negotiate with him. Today, the city wants to create a "tourist attraction" at the site. Seems a bit late, don't you think?

# PART II
# TROY LANDMARKS

# History Is for the Dogs

In 1932, you could buy a gallon of milk for less than fifty cents, fill up your gas tank for less than a dollar and be thrilled that Amelia Earhart had just crossed the Atlantic on a solo flight.

It was also the year that a small family restaurant, no larger than a railroad car, opened on a crowded street in downtown Troy at 111 Congress Street. The Quick Lunch was the vision of Greek immigrants who wanted to operate their own family business. It was a time when the country was in the grip of a deep depression, with more than one-quarter of the labor force workless.

The Quick Lunch menu was simple. They served up a small, three-and-a-half-inch hot dog on a bun with special meat sauce, mustard and onions. The hot dogs were made locally at the Troy Pork Store down the street on the corner of Fourth and Ferry Streets. It, too, was founded by an immigrant, Charlie Comertz, a few years earlier in 1918.

We think of hot dogs as being as American as apple pie but they've been around for centuries. Hot dogs are technically sausages, mentioned in Homer's *Odyssey* way back in the ninth century.

The city of Frankfurt, Germany, makes claim that the "frankfurter" was developed there in 1484. Another claim is that Johann Georghehner, a butcher living in Coburg, Germany, made the "dachshund" (or "little-dog") in the late 1600s and traveled to Frankfurt to promote it.

Vienna (Wien in German), Austria, claims ownership, pointing to the word "wiener," another name for the hot dog.

How did the "dachshund" end up on a bun? One story says a German immigrant sold them from a pushcart in New York City's Bowery during the 1860s along with milk rolls and sauerkraut. In 1871, Charles Feltman, a

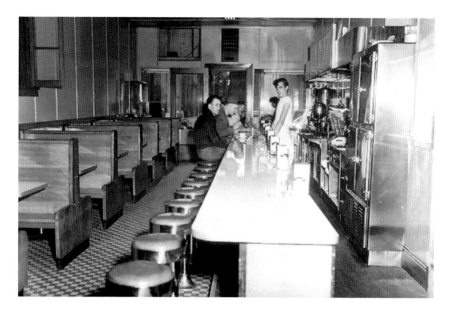

The counter at the Famous Lunch on Congress Street about 1940. The Famous has been serving delicious little hot dogs since 1932. *Courtesy of Scott Vasil, Famous Lunch.*

German butcher, opened up the first Coney Island hot dog stand, selling more than three thousand dachshund sausages in a milk roll his first year.

Hundreds of them were eaten at the Colombian Exposition in Chicago in 1893, and that same year they became a hit at baseball parks, sold by Chris Von de Ahe, owner of a St. Louis bar and the St. Louis Browns baseball team.

The term "hot dog" was coined in April 1901 at the New York Polo Grounds as Harry M. Stevens (1855–1934) sent his salesmen out to purchase all the dachshund sausages and rolls they could find. Shortly after, they were selling hot dogs from portable hot water tanks yelling, "They're red hot! Get your dachshund sausages while they're red hot!" Hearing this in the press box, sports cartoonist Tad A. Dorgan of the *New York Journal* drew a cartoon of hot, barking dachshund sausages snuggled in rolls. Since he couldn't spell "dachshund," he simply wrote "hot dog."

The hot dog and bun were introduced during the Louisiana Purchase Exposition in 1904 St. Louis by Bavarian Anton Feuchtwanger. He loaned white gloves to his patrons to hold his hot sausages. Since most of the gloves were never returned, he asked for help from his brother-in-law, a baker, and the bun was invented. Also, "Hot Dog!" was used as an exclamation on banners above the vendors at the World's Fair.

The thought of hot dogs became so ingrained in the public's conscience that the Coney Island Chamber of Commerce banned the term "hot dog" on the Coney Island boardwalk in 1913, and instead called them "Coney Island Hots."

In 1954, a young local marine stationed at the U.S. embassy in Moscow missed having his Troy hot dogs, so he convinced the embassy staff to fly in a few dozen on a KLM Royal Dutch Airline for the ambassador's fifty-fourth birthday party. "Operation Hot Dogs" made local and national news and the name of the Quick Lunch was forever changed to the Famous Lunch. The Famous continues to serve up those little hot dogs after seventy-six years in business.

As a boy living across the street, I would run over to the Famous and wolf down eight dogs, French fries and a Canada Dry, and still have money left over for the best rice pudding in the world. In those days, Steve Vasil, his brother Nick and Charlie Cagiandus would serve the packed house each day. Greek immigrants themselves, they started working at the Famous during the mid-1950s. Steve made the paper (the *Troy Record*) shortly after, when he cast his first vote as a new American citizen. As he put it, it was his "holiest moment," and the *Record* mentioned it in an editorial.

I was just a young boy no older than six or seven when I started eating at the Famous, and I loved sitting in the booths. The wooden backs seemed to go up to the enameled steel ceiling. Each booth had a small jukebox connected to the main player that was sitting by the phone booth at the far end of the eatery. A quarter got you three plays, mostly Elvis.

I would sit there for long periods of time, between bites, listening to the debates about everything under the sun. Steve, Charlie and Nick all had a point of view and loved to share it, no matter what the subject. I probably learned more about world events in one hour at the Famous than from a year's worth at elementary school. Years later it dawned on me that it was only natural for free-spirited discussions to take place there. After all, wasn't democracy a Greek invention?

Most of the buildings on Congress, between Fourth Street and Fifth Avenue, are gone now. Nick and Charlie passed on. Steve and Nick's wife Kay later ran the Famous for a while. Steve retired in 1996 and his son Scott, a graduate of RPI's Industrial Engineering Department, now carries on the tradition.

Many of the same folks I saw as a kid still eat there today. The spirited discussions still take place every day. The hot dogs are still great. The dessert pies and buns are made across the river in Watervliet. The rice pudding is still the best in the world and made in the backroom. The prices are right. The Famous represents plain old-fashioned hometown-made food and real customer service—a rarity.

I make it a habit to go to the Famous a few times every month. It's like a security blanket. When it seems that everything in the world is going to pieces, sitting in the Famous for a few moments is like stepping back in time. Every so often, Steve would pop out from the back after helping Scott on a busy day, and I knew things were just going to be fine. Some things should never change.

## LET'S GET SQUARE AGAIN!

For those readers over the age of thirty, the words "Franklin Square" bring back memories of a busy commercial area; it was a time when Troy was a bustling city of seventy thousand. Franklin Square was a city block filled with thousands of Trojans spending their money on everything from candy to furniture, enjoying a movie, eating Chinese food or making a bank deposit.

Franklin Square was one of Troy's busiest commercial centers and was located at the intersection of Grand, Fourth, River and Federal Streets. It was connected to Chatham Square, the area that connected King to Federal and River. Passenger and freight trains ran down the middle of it on the way to Union Station. This block of hundreds of nineteenth-century buildings ran north to Fulton Street, where it met Third Street and the Market Block.

Franklin Plaza (the old Manufacturer's Bank) is the only remnant of the entire set of squares.

Yes, Virginia, Troy had shoppers—thousands of them. When I was a youngster in the seventies, winter was the time of year when you literally walked shoulder to shoulder—three deep—with fellow Trojans doing their Christmas shopping. At night the city was lit up like a Christmas tree. Carolers went from store to store, singing holiday cheer. Stores were open until midnight.

Let me give you an idea of what existed in that block (actually a triangle instead of a square): three bars, three taxi stands, three manufacturers, two photo shops, six furniture stores, ten clothing stores, two jewelers, three candy stores, five department stores, eleven restaurants, ten shoe stores, one theatre, two drugstores, one bank, two bookstores, one dancing school and many other types of retail establishments and offices.

Then one day in the seventies our politicians and business leaders thought it would be a good idea to tear it all down! Without beating a dead horse, we have been suffering from that decision ever since. Why not reverse that decision? Bring back Franklin Square!

Why not? Most of the area that comprised Franklin Square is vacant land except for a small motel, a restaurant and a parking garage. Keep the garage,

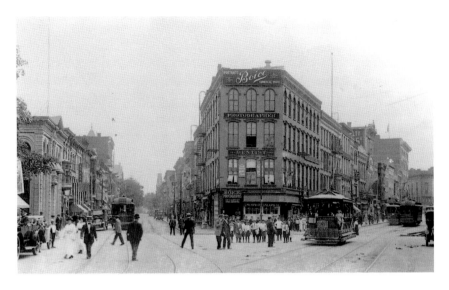

A busy Franklin Square about 1915. Notice the abundance of trolleys and the newspaper boys standing in the square. The Boice Photographic Studios were located here and many of Boice's nineteenth- and early-twentieth-century photographs of Troy survive. *Courtesy of the author.*

incorporate it and the motel into the new square, demolish the box on the river—it prevents the extension of the proposed bike path anyway.

A brand-spanking-new Franklin Square would be state-of-the-art retail, office and living space—designed, of course, in nineteenth-century scale to blend in with the surrounding city. In fact, if the city can find an architect with imagination, they could recreate the entire look and feel of the original square.

Here's what I think should be in the new Franklin Square: Ben & Jerry's, Macy's, a Bass shoe outlet, Hiro's, Toys Я Us, Sears, Borders Books or Waldenbooks, Book Outlet, Kinko's, Starbucks, JCPenney, AC Moore, Price Chopper, Troy Pub & Brew (satellite) and OfficeMax, to name a few. I'm sure you have your own wishlist, but you get the picture!

It's my opinion that Troy needs a major booster shot, not just a small vaccination, to get it back to economic health. For every new business that moves in, two leave. By building a complete new city block, with all those amenities the MTV generation needs, it would entice national chains, yes, even a major department store, to come back to the city (and even encourage the redevelopment of our existing surrounding historic structures). Troy could use a catchy jingle to bring people into Troy to shop once again. Here's one I wrote just for the occasion—sung to the tune of "Yankee Doodle":

*Mom and I went down to Troy,*
*I also took my honey;*
*And all ran to new Franklin Square,*
*To spend our hard-earned money.*
*Franklin Square, keep it up,*
*Franklin Square, it's dandy;*
*In downtown Troy, a great big step,*
*Buying here is handy.*

Or, perhaps the retailers could wear buttons: "It's Hip to be (Franklin) Square," or some other corny slogan that always seem to be necessary with these projects.

Seriously, folks, visitors to this city often tell me how much they like to walk around and look at Troy's historic architecture. Ironic, since you can no longer even buy a pair of shoes in downtown Troy!

## SKELETONS, POLITICS AND PIGEONS

The southeast corner of Third and State Streets, now called Barker Park, has an interesting but odd history. While looking at the small park, one would never guess that it was the final resting home of some of Troy's earliest settlers, and where many of the city's nineteenth-century political decisions were made. You see, it was originally a village burial ground, and later the site of Troy's first city hall.

Originally, it was owned by the Mohican Indian Annape, but later became property of Jacob D. Vanderheyden. On May 10, 1796, Vanderheyden deeded to the village trustees of Troy a plot to be used as a public burial ground. It covered all the land from Third Street, running east along State Street to the alley and south to the First Baptist Church. More than two hundred people were buried there before the city forefathers decided it was a good place for a city hall, eighty years later.

The city at the time was using part of the Athenaeum building, which was built in 1845 by the Troy Savings Bank, on First Street (now a parking lot). On May 7, 1869, the "City-Hall Company of the City of Troy" was created and authorized a committee to locate and purchase a site to build a new city hall. The original capital was increased so the Troy Savings Bank could contribute from their funds to provide rooms in the new building for banking. Moreover, the bank was to jointly own the building with the City of Troy, an arrangement

City hall, seen here on the left about 1913, was replaced by Barker Park after the building burned to the ground on October 28, 1938.

that certainly would not fly today. This idea was dropped when the trustees of the bank decided to build the beautiful building they have on First and State Streets.

In 1875, there was a move and petition drive to buy the Athenaeum building from the bank, but Mayor Edward Murphy Jr. opposed it, and recommended the purchase of the Third Street burial ground instead. The Troy Common Council ignored the mayor, and approved the purchase of the First Street building on April 1. Murphy didn't appreciate the April Fools' joke and vetoed it two weeks later on the fifteenth. The Third Street Burial ground was finally selected on June 8 and the Vanderheyden heirs were paid $10,000 to give up any rights to the land, even though the original Vanderheyden donated it in the first place. A month later, the city hired architect Marcus Cummings to design the building.

Before any construction could take place, the city had to move 208 people buried in the old cemetery and it took almost a month to complete (July 12–August 1). Most of them were relocated to Oakwood Cemetery. A few of the graves between city hall and the church were left, including the grave of Platt Titus, who died in 1833 and had operated the Troy House (now senior citizen housing on First and River Streets) for about thirty years. Apparently the unmoved graves were covered over with sod. There is a small monument between the back of the Catholic church and the First Baptist fence that appears to indicate that in 1937 the rest of the graves were dug up and reburied at Oakwood. The stone says the graveyard was abandoned in 1873, which

may account for Murphy wanting to buy it in the first place. It also says the graveyard began in 1743, which is earlier than reported.

The new city hall building was occupied in October 1876. It was an impressive structure, 150 feet long and 83 feet wide, built of Philadelphia pressed brick. A clock was placed in the tower in August 1885 and was illuminated at night by a special automatic gas device attached to a timer. In addition, a six-thousand-pound fire bell was placed in the tower in 1887, cast by Troy's Jones Bell Foundry Company. Strangely, there are very few photographs of the interior of the building. Many exist of the exterior, and several were taken when the building burned, under suspicious conditions, on October 28, 1938.

According to former Trojan Stuart Peckham, after the fire and before the site was converted to a park, a promoter built a small bungalow on the sidewalk and sold tickets for it. Eventually it found its way to Elmgrove Avenue, across from Emma Willard's athletic fields. After the site was cleaned up and landscaped, it was named Barker Park, after C.W. Tillinghast Barker, a Troy industrialist, according to local historian Carl Erickson.

Stuart Peckham also tells me that kids used to refer to the park as "A-Hernia Park," after the mayor of the time, John J. Ahern. He also remembers that in 1942, a miniature Japanese submarine was exhibited there—perhaps as a rallying cry during the war?

I remember the park as a kid in the '60s, but we called it "Pigeon Park." Thousands of pigeons made the park their home. They were well-fed too. "Jim the Peanut Man" had a cart on the corner where you could buy fresh roasted peanuts or popcorn for a dime. Someone recently told me that Jim's cart is still around but I can't remember where it is.

Park visitors would hold out their hands while the pigeons cooed and wobbled their way to grab the goodies. I remember one elderly woman who we called the "pigeon lady" because she was literally covered with pigeons—on her head, shoulders, arms, lap, etc. I'll leave it to your imagination!

In 1964, St. Anthony's Catholic Church decided to abandon the beautiful wooden structure on the corner of Fourth and State Streets. They convinced the city to give or sell them half of the eastern part of the park so they could build the present church there in 1964. That also meant the removal of the great cast-iron fountain that sat in the center of the park.

During the '60s and '70s, the park became a peaceful hippie hangout and presently you could say the "park" is in need of a good makeover!

It's time to take back the park and make it a place for people once again. An integral part of rejuvenating Troy is to get families to shop, eat and play

downtown. My suggestion is to change it to a real children's park with wooden representations of Troy steamboats; perhaps a small Burden water wheel that could serve as a Ferris wheel, where kids can sit in the "buckets"; a little Dutch house; slides; and other fun things. A kids' park would encourage families to come downtown again. While Dad is watching the kids in the park, Mom can shop (or vice versa). All that activity would make the kids hungry so it would help our downtown eateries too! Oh yeah, if there are any remaining gravestones found on the site, they should be restored with a fence placed around them and an interpretive sign.

## TROY'S SECRET MUSEUM

One of my favorite buildings is the Troy Public Library (Hart Memorial), located on Second Street near Seminary Park. It truly is a remarkable piece of architecture in American Renaissance style and has been serving Trojans at that location for over one hundred years.

The financing and lot for the building with the white marble facade were given by Mary E. Hart in honor of her husband William Howard Hart, and was designed by the New York City architectural firm of J. Stewart Barney and Henry Otis Chapman. As one European friend of mine remarked, it's like having a bit of the Renaissance in downtown Troy.

When the Young Men's Association and Free Reading Room joined forces in 1879 to create the library, Troy was a leading industrial city. It was also famous for its educational institutions like Amos Eaton's RPI and Emma Willard's Female Seminary.

So "Renaissance" is a fitting term for the library because, in reality, it provided much more than books.

Aside from the fact that more than twelve thousand volumes were available for residents of the city when it opened in 1897, the library also contained a wealth of artwork and natural history specimens; in fact it could easily be described as a library/museum.

Even today, inside and along the elaborately carved marble walls, you will find nineteenth-century paintings, friezes, marble and bronze statues, engravings, stuffed birds and other Americana, including an original Tiffany window. While economic strains over the years have forced the library to sell some of its holdings, it still has an impressive collection.

Two marble sculptures instantly grab your attention. The life-size *Esmeralda & The Goat* (from the *Hunchback of Notre Dame*) attributed to Antonio Rossetti of

Rome (1867) is in the northwest corner of the lobby (an identical piece is at the Union League in Philadelphia).

Similarly, as you go up the marble stairs to the second floor, the *Greek Atalanta, daughter of Iasius, king of Arcadia*, greets you on the landing. This full-size marble piece is attributed to William H. Rinehart (1825–1874), a Maryland farm boy and stonecutter who became one of America's most skilled nineteenth-century figural sculptors. In 1855, he established a studio in Rome and stayed there. His other work includes the carved reliefs (*The History of Justice*) for the bronze doors of the Senate Chamber in Washington, D.C., and the Paine Mausoleum statue in Oakwood Cemetery. Most of his works are at the Peabody Institute where there are casts of forty-two figures, reliefs and busts and three marble originals, including his masterpiece, *Clytie*.

Right above *Atalanta* hangs a 3-by-18-foot plaster frieze mural called *Six Horses and Nine Men*, a smaller version of the original work 1 meter tall by 160 meters in length on the Parthenon, one of the largest relief sculptures of the ancient world. It depicts the Panathenaic procession, a procession that took place during the Panathenaia, an ancient Athenian festival that celebrates Athena's birthday for twenty-eight days during the summer.

Along the walls in the Reference Room on the second floor are several paintings by William R. Tyler (1825–1896) and Frank Fowler (1852–1910).

Fowler's two paintings, which flank the sides of the large ornate fireplace, are fittingly of William Howard Hart and Mary Hart, benefactors of the library. Fowler, who studied at Ecole Dess Beaux Arts in France, and with the famous French painter Carolus Duran in Florence, had his studio in New York City.

Some six paintings from William R. Tyler, probably painted between 1870 and 1880, reveal land and seascapes with a touch of Hudson River School style. Tyler moved to Troy when he was eighteen to paint scenes on the panels of coaches for carriage maker Eaton and Gilbert. In 1858, Tyler had a studio on Broadway.

Two paintings by Tyler are historical in nature—*The Telling Shot*, a battle between the Civil War ships *Kearsage* and *Alabama* (built in Portsmouth Yard in 1861, this steam- and sail ship is best known for defeating the Confederate raider *Alabama* off the coast of France in 1864), and my favorite, *The Conflict Between the Monitor and Merrimac at Hampton Roads, March, 1862*. The hull plates for the *Monitor* were made here in Troy.

A painting of a mill scene by another local artist, Joseph Hidley (1830–1872), hangs in the administration office. Hidley is noted for his paintings of Glass Lake and Poestenkill Village.

I cannot think of any other local library that has this unique collection of books and artifacts in our area.

Marble pieces not already discussed include one inside the Children's Room, tucked in the corner: a beautiful carved figure of a child with legs crossed, reading a book, although no attribution is given. Another lovely piece of marble, a silhouette, called *Il Penseroso*, is framed on a pedestal next to the fireplace in the reading room upstairs. It was created by Launt Thompson (1833–1894), an Irishman who studied with Erastus Dow Palmer and was a member of the famous Academy of Design. The piece was purchased in 1861 for the library and is based on Milton's moody poem *Il Penseroso* or perhaps Handel's musical version of it.

*Sleeping Peri*, a marble bust by Erastus Palmer and created probably in the 1850s, is now in storage in the basement. Palmer, an Albany carpenter turned artist became world famous and executed about one hundred cameo portraits and many portrait-busts, such as of Alexander Hamilton, Commander Matthew C. Perry and Washington Irving. The *Sleeping Peri* and three others (*The Emigrant Children*, *The Little Peasant* and *The White Captive*) are considered his best works. In Persian mythology, a peri was a supernatural being or fallen angel who was denied paradise until penance was obtained. Originally agents of evil, they were identified as benevolent spirits in later mythology. (An anonymous poem inspired by this statue can be found in "The Sleeping Peri. Lines Suggested by Palmer's Statue." *The Continental Monthly* vol. 4, issue 2 [August 1863], pages 159–60.) A bronze clock with Christopher Columbus seated on a coiled rope sits on the mantel in the administration office and was made by the sculptor Louis Cox.

Throughout the library, you can find prints depicting various Troy scenes such as the falls at Mount Ida, or scenes of Troy from different vantage points, all nineteenth-century views.

For Civil War buffs, upstairs in a small room off of the fireplace, sitting on top of a bookcase, are the remains of an American battle flag that left for war with Company E of the Harris Light Cavalry on August 12, 1861. This tattered flag was the first to enter the fortifications of Centerville, Manassas, as well as Falmouth, and one of the first into the Battle at Fredericksburg. It was given to the Young Men's Association in 1905—"to whose keeping it has been so handsomely committed, with all the care that so precious a memento of the valor of our Troy soldiers in the war for the salvation of the republic deserves to be kept."

Next to the flag is a framed original eighteenth-century copy of one of Lansingburgh's first newspapers, the *Farmer's Oracle*.

As you begin the flight downstairs to the basement on the Ferry Street side, you are confronted with a large exhibit case filled with stuffed birds from around the world. As a kid, I also remember one filled with butterflies and

a third I believe contained larger animals. While the cases are still there, the specimens are gone. Many of the natural history specimens were donated to the library when the Troy Lyceum of Natural History folded. This was one of the first such scientific societies in America and was founded by Amos Eaton and others in 1818. The rocks, minerals and fossils were given to RPI and the natural history material went to the library.

We have already discussed the various works of art that grace the interior of the building, but the art even extends to the building's windows.

Behind the sign-out desk is a large Tiffany window, known as the *House of Aldus*. Donated by patron Mary Hart, it depicts a scene showing Aldus Manutius (1450–1515), an Italian scholar and printer, presenting proofs of an octavo edition of Dante's *Divine Comedy*. Aldus published Greek and Latin classical texts, grammars, religious writings, contemporary secular writings, popular works, political and scientific writings, history and geography. After all, this was the Renaissance!

Also in the scene is Pietro Bembo, who edited Dante's work. Bembo (1470–1547) was a prominent humanist, poet and churchman, and involved with the Aldine Press from the start. The first book issued by Aldus, Lascaris's Greek grammar, was printed from a copy provided by Bembo. Bembo's own first work, *De Aetna* (1496), and his editions of Petrarch's *Rime sparse* and Dante's *Commedia*, were printed by Aldus.

Also in the window scene is Bolognese-type cutter Francesco Griffo, the engraver of the type (he cut most of Aldus's fonts, including a new italic font), and Alberto Pic, a former student and patron of Aldus who supplied the funds to start his printing company in 1490.

Aldus is given credit for creating typefaces and popularizing the octavo format for books. This page size, from five by eight inches to six by nine and a half inches, is the standard form we use today. Prior to this, books were large folio sizes, not your sit-down-and-curl-up-with-a-book approach common today.

The Tiffany window was designed by Frederick Wilson (1858–1932), one of Louis Tiffany's best freelance designers. Louis Comfort Tiffany was the leading designer and manufacturer of stained-glass windows between 1870 and 1920, and Troy has several of them, mostly in churches.

The Troy Library truly is one of the city's crown jewels, but it has taken an economic hit over the years. Even when Mary Hart originally contributed a challenge grant to raise enough working capital, it didn't materialize, and the money had to be returned. After changing the name to the Troy Public Library in 1903, the City of Troy appropriated a small amount of money.

During the city's economic crash in the '90s, the library lost much of its funding; while it slowly has been getting increases from the city and county, the bare fact is that our library gets about half of the twenty dollars per capita enjoyed by other libraries around the state. This has severely limited the ability to add to the collection and stay open, and since they can't scale back the already-small, overworked staff, the only thing to do is cut corners—building maintenance and little increase in collections. It should be pointed out that besides this building, the library also maintains the 175-year-old former Lansingburgh Academy and School 18 branches.

Even with these pressing times, the library has added a computer room with free access to computers. They have a Children's Room second to none and, for you history buffs, a Troy Research Room.

What can you do to help the library? Join the Friends of the Library (they have book sales and other fundraising events). Perhaps you can donate computers you don't use anymore? I would like to see everyone purchase a brand-new book for the library to increase the collections. Before you do this, ask the library staff what categories are needed.

There are a number of stained-glass windows throughout the library that have panels in them for donor names. Perhaps an annual drive to fill up those panels each year could raise additional funds. Donate a thousand dollars and your name is placed on a panel for a year, perhaps?

Libraries are sanctuaries where everyone, regardless of age, race or sex, can absorb the collective knowledge of society. Truly a democratizing process such as this must be supported by all those who directly or indirectly benefit from it.

## Troy's Village Green Still Green

One of the joys of visiting small rural communities is admiring their village greens—small parcels of land set aside for the benefit of the entire community. They're often the scenes of commencements or inaugurations, ends of parades, picnics or other festivities, and almost always are grassy parks.

Troy still has its original village green. Seminary (or Congress) Park is a small parcel along Congress Street, bordered on the east by Second Street, on the west by First Street, and on the south by Russell Sage College. Seminary Park has remained virtually the same for the past two hundred years.

The area that is now downtown Troy was laid out into lots in 1786 by Jacob D. Vanderheyden. Philadelphia and Savannah (via Lansingburgh) were used as models for Troy, consisting of a layout of regular squares, streets and alleys, except for River Road that followed along the course of the river.

Vanderheyden's farmland was laid out in this rectangular fashion into 289 lots, each 15 feet wide by 130 feet deep. Streets were 60 feet wide, and alleys were 25 feet wide.

Benjamin Covell was the first to select a lot—no. 5—on the west side of River Street, becoming the "first" Trojan.

To put this in perspective, Lansingburgh to the north was already a substantial village with four to five hundred inhabitants, while nearby Albany had three thousand. The residents of Troy, then known as Ashley's Ferry, or Vanderheyden, soon changed the name of the village to Troy on January 5, 1789. Almost ten years later, on February 6, 1798, Troy was incorporated as a village and boasted a population of about fifteen hundred people (surpassing Lansingburgh).

Troy received its first park even before incorporation. On May 10, 1796, two years before incorporating, Jacob D. Vanderheyden deeded over three lots—"Bounded on the north by Congress Street, east by Second Street, south by Lot 115 and west by an alley." It was to be used as a public square. This original park would be about half the size of the present one (extend the alley on Congress south through to Sage).

Lot 115 was the site of Moulton's Coffee House, later used by Emma Willard for her Troy Female Seminary (Emma Willard School), and now Sage Colleges. This deed also gave permission to construct "a public schoolhouse or academy if judged proper by the inhabitants." They didn't. Vanderheyden received five shillings for the deal, roughly the weekly wage of a carpenter during Elizabeth I's reign, or the cost of about fifteen pounds of candles.

The other half of Seminary Park came from land owned by the First Presbyterian Church.

In 1792, a small wooden meetinghouse was built on the east side of First Street near Congress on land donated by Jacob D. Vanderheyden, a member of the church. The following June, the Reverend John McDonald delivered the first sermon at the new house of worship. A historic marker now rests on the site. Under the church was built a vault and the remains of Vanderheyden's mother and father were interred there. I haven't been able to determine if they are still there or were moved at a later date.

In 1795, Jacob D. deeded over three more lots to the church, lots 86, 87 and 88. In 1819, a small session house was erected to the south of the meetinghouse.

On July 18, 1834, the church swapped land with the city. Lots 86, 87 and part of 88 were given to the city for lots 85 and 84, for the purpose of building a larger church. There was a small reservation placed on lot 86 "so that a small part of said meeting house so to be erected only shall stand upon said lots with a view that the residue of said lots may forever be kept open and kept unoccupied by any building and be enclosed as a public park and yard in front of the same meeting house."

A parade marches past Seminary Park, on the left. This is the first village park given to Troy by Jacob Vanderheyden. *Courtesy of Tom Clement.*

It was also stipulated that the portico of the new church not extend into lot 86 by more than fifteen feet. A right of way was also granted so that people could enter through Congress and First Streets—a gate was to be placed on First, another on Congress and another on either street west of the alley. Construction for the new church began in 1835. The church today stands as a Greek Revival building that looks like the Parthenon, and is now owned by Russell Sage.

Over the years, the alley to the west was assimilated. Paths were created. Fences were erected and removed. Some landscaping occurred to prevent people from walking in the grass. Aside from the war memorial there and some benches, Seminary Park has remained one of Troy's emerald treasures for all citizens to use.

Let's hope it always remains so.

## WHOSE "GREEN" IS IT ANYWAY?

What's happening to Troy's parks? Are they being taken over by special interests? Perhaps! Troy, including the "Burgh," has about three hundred acres of parkland for the enjoyment of all its forty-five thousand citizens. This

A beautiful panorama of Troy from Mount Ida in 1909, looking northwest. Troy was in its heyday at this time. *Courtesy of the Library of Congress.*

includes Beman, Frear, Prospect and Seminary Parks in Troy proper, along with Knickerbocker, Powers and the village green in Lansingburgh.

A cursory review of these parks reveals a pattern of abandonment over the last twenty years and recent rediscovery of at least one park. Troy received its first park before it was even incorporated. Jacob D. Vanderheyden gave the village of Troy three lots for use as a public square on May 10, 1796; today that comprises Seminary or Congress Park, between First and Second Streets. It was enlarged when the city traded some lots with the Presbyterian Church. Many events took place in this park throughout the years.

The park apparently has been claimed by Russell Sage College since they have incorporated it, with fencing, into their massive renovation and face-lift project. While they say it is a "public common" on a small plaque at one of their entrances, I am very suspicious. They have paved way too much of the park in my opinion.

The village green that Jacob A. Lansing donated to the Village of Lansingburgh on July 4, 1793, at 112th Street, now has three quarters of the park taken over by baseball and is fenced and locked. Only about a quarter of the park is available to all residents.

In 1917, the William H. Frear family donated 22 acres of land for a park. Twenty more acres were donated by Jennie Vanderheyden in 1923, and another parcel by the Eddy estate resulted in the present-day 150-acre Frear Park. Much if not the majority of this park has been taken over by a golf course. In fact, it's called the Fear Park Golf Course!

Prospect Park, also known as Warren Park, sits atop Mount Ida overlooking the city, and was created in 1903 after the city purchased it from the Warren family. The park was beautifully laid out by city engineer Garnet D. Baltimore, who was the first African American graduate of RPI. Prospect Park had

winding roads, outlooks with towers that permitted viewing the Hudson River Valley for a distance over twenty miles, fountains, a band shell, playgrounds and flower gardens. The former residences of the Warren family were converted to a museum and casino. It even had a pool that was popular when I was a kid.

Prospect Park lost its pool, the buildings burned or were torn down and other amenities disappeared between the '70s and '90s. Trojans abandoned the park. However, thanks to a dedicated team of volunteers, the park is slowly coming back to life.

The alarming trend here is that these parks were designed and acquired for all Troy citizens, the key word being *all*. They have been taken over by special interest groups. Golf courses and locked ballparks are not for everyone. I have nothing against either sport, but the large areas they need preclude other uses. On the other hand, perhaps this is the only part of Troy's population willing to use the parks? Beman Park (1879) and Knickerbocker Park (1924) seem to me underutilized.

Perhaps the reality of the situation is that there isn't a population anymore that enjoys picnics, strolling and passive park use. Perhaps we are just too busy zooming around in cars, talking on cell phones, logging onto the Internet or playing Xbox. It's a real shame. In the meantime, playing ball might simply be better than the obvious alternative. As one developer told me years ago, "You want green space? No problem, we'll paint it any color you want."

## A Trojan Snapshot

Troy's industrial growth during the nineteenth century saw a rapid rise in population. All of these new Trojans needed a place to live, and while many

A small boardinghouse located at Sixth Avenue and Jacob Street. *Courtesy of the author.*

aspired to own their own homes, many rented rooms from homeowners who had the extra rooms, or stayed in buildings built specifically as boardinghouses, or hotels that served as such.

In the 1890s, Troy boasted twenty-nine hotels and thirteen boardinghouses. Other lodgings were known as "men's" hotels and served those who came into the city for a short spell. For example, "colliers" from the rural townships

hauled charcoal to the city iron furnaces and needed a room for the night. There were even special boardinghouses for single women who came to Troy to work in the collar industry. One such building still exists near Hoosick and River. Unfortunately, during recent times, boardinghouses became better known as "flophouses" for those on the lower end of the economic scale.

While growing up in Troy, I remember boardinghouses on Federal, Eagle, Ferry and Grand Streets, the Clark House (Brown Building), and "Eddies," both on Broadway, and the old Trojan Hotel.

Not everyone who lived in boardinghouses was poor or destitute. Wendy Gamber, a history professor at Indiana University, wrote a book about boardinghouses and their occupants (*The Boardinghouse in Nineteenth-Century America*, John Hopkins University Press, 2007). In a paper published in the March 2005 *Journal of Urban History* ("Away from Home: Middle-Class Boarders in the Nineteenth-Century City") Gamber talks about the lives of three borders. One is a Trojan who stayed in the Clark House at 207–215 Broadway from 1880 to 1890. It is a fascinating look into the life of one Trojan and gives us a glimpse of what Troy was like during the Victorian era.

Catherine Thorn was the wife of a Troy doctor and moved into the Clark House in 1880, five years after her husband died. At age seventy-eight, she decided to rent her Third Street home and make the Clark House her residence, becoming its oldest resident. Catherine joined a "family" of occupants that included male clerks, salesmen, single women (mostly teachers), married couples and widows. It was a diverse family of unrelated Trojans.

The Clark House was a busy place and located in the heart of Troy near Monument Square. Mrs. Helen Price was the landlady. Retail shops occupied the first floor and friends and families entered the hotel daily to visit the residents. Across the street was the fashionable Mansion House hotel, where the daily stagecoaches boarded passengers, and farther east, the Keenan Building, filled with more retail like Tippin's Jewelry Store. The Cannon Building, just west of the Clark House, was home of Frear's Cash Bazaar, one of the first department stores.

Mrs. Thorn made her daily visits to friends. Perhaps she stopped in to Levy's tailors across the street, or Brown's Confectionary on the first floor of the Clark House for a treat. She also was the host of friends and relatives, her attorney, her husband's former patients and even her former servant ("poor old Biddy"), according to Professor Gamber, who writes that Thorn considered these people "visitors from abroad."

Thorn's diary describes her relationships with several people, including Fanny Whittemore, a music teacher, who accompanied her to the Unitarian Church on Sundays (now St. Anthony's parking lot at the corner of Fourth

and State), social events and musical reviews. Their arguments and subsequent makeups are noted as well. Another member of the Clark House, David Briggs—who, while a boarder, rose from salesman to co-owner of Marshall and Briggs's collar manufactory—often brought Thorn copies of newspaper articles and helped her in her own writings to the Troy *Daily Times*, located just a few feet east, while Thorn reciprocated with advice on matters of love and affection. She writes of the death of Sarah Buell, who was laid out in the parlor of Clark House and how they comforted her husband and children who continued to live there.

In the evenings, boarders often gathered in each other's "private" parlors. According to Gamber, by the late nineteenth century, some boarders typically rented suites of two rooms—one to receive visitors, and the other as a bedroom. To pass the time, the boarders played cards or made music. Thorn played the piano while others sang.

In some ways, the Clark House was like most other homes in Troy. Residents interacted with friends, argued, made up, laughed, cried and tried to live a good life. While the makeup of boardinghouses may have changed frequently, longtime residents like Thorn, Price and Briggs were as much a Troy family as any. Thorn outlived her landlady; she died in 1890, at the age of eighty-nine. Briggs was a pallbearer at her funeral.

Today, the Clark House is waiting for restoration.

# Let the Light Shine Through!

The audience that packed the auditorium at Emma Willard School one evening learned that Troy was the "Motherload of Tiffany." Harold W. "Bill" Cummings of Cummings Studios in North Adams, Massachusetts, was referring to the many Tiffany windows remaining in this city. Cummings, and window conservator extraordinaire Diane Rousseau, presented an illustrated talk on the recently completed two-year restoration of Tiffany windows located in St. John's Episcopal Church on First and Liberty Streets. The talk was sponsored by the Rensselaer County Historical Society.

Tiffany windows are world famous for their quality and depiction of religious, historic and pastoral themes, and Troy has several surviving pieces scattered throughout the city. In addition to those at St. John's, you can find Tiffany windows at St. Paul's Episcopal, First Presbyterian Church (Bush Memorial Center), St. Joseph's Catholic, the Episcopal Church of the Holy Cross, the Gardner Earl Memorial Crematory and Chapel, Kemp Mausoleum

(Oakwood Cemetery), Troy Public Library and the First Presbyterian Church of Lansingburgh.

It has been written that St. Joseph's has the largest assemblage of Tiffany windows of any church in America, but the recently restored set of windows at St. John's is the only set of lancet (tall and narrow and set in a lancet arch) windows Tiffany ever produced. The multipaneled scene depicts "St. John's Vision of the Holy City." Tiffany artist Agnes Northrop designed this masterpiece. She joined Tiffany in 1884, when she was twenty-seven years old.

However, time has not been kind to the windows. The elements and previous restoration work have taken their toll. Rousseau and her team painstakingly restored the windows, and if you were privileged to have seen her slide show, you learned that the task was monumental. There are over eight thousand individual pieces of glass in this window set: glass that's spun, crackled, warped, bent, pressed into molds and faceted into jewels.

Tiffany windows are built in layers, which provides incredible depth and dimension, she said. She explained that the "Holy City" window is a three-layer window, with individual areas of emphasis that are four and five layers deep and feature up to ten surfaces. The Holy City itself is made of thousands of tiny pieces, with large white plates on the interior that make it appear as if it's receding behind clouds. "The intent is to dazzle the viewer, to make the Holy City happen as literally as the materials would allow," according to Ms. Rousseau.

Viewing a Tiffany window is like enjoying a great symphony. When you sit back and listen, you absorb the combined effect of thousands of notes playing off each other and experience the emotion of the totality of the piece. Likewise, when you sit back and stare at a Tiffany window, you are absorbing the combined effect of reflected light on thousands of pieces of colored glass, evoking a visually emotional response.

Louis Comfort Tiffany (1848–1933) was the son of Charles Lewis Tiffany, founder of Tiffany & Company. The remarkable fifty-seven-year career of Louis C. included designing jewelry and lamps, as well as windows and decorative glass, and he even received a patent for his opalescent window glass in 1881. His work was not only commissioned for churches, but also by the likes of Mark Twain and Cornelius Vanderbilt.

Today, Tiffany creations sell for large sums. A round of applause must be offered to the custodians of St. John's for restoring the windows for all Trojans to enjoy, rather than offer them up to an auction house. The windows are estimated to be worth several million dollars.

What also strikes me as remarkable is the existence of companies like W.H. Cummings Studios that have assembled the kind of talent needed to restore

such works of art with not just the technical expertise, but also with the love and care that is clearly exhibited in their work. They strive to leave as little of their mark in the restoration as possible, so that the work of the original artist becomes center stage once again.

These Tiffany jewels that dot the Troy landscape are just another reminder of the city's rich history. The restoration of "St. John's Vision of the Holy City" is another example of what I like to call the "heritage renewal" going on in Troy. The Hudson Mohawk Industrial Gateway presented to St. John's their annual preservation award for the restoration work.

It may take one project at a time, but in the not-so-distant future Troy will replace "Collar City" with the new title of "Renaissance City."

## WHO'S TO BLAME?

The Albany Iron Works was in operation 150 years before the furnace was shut down for good in 1989. Admittedly, a pretty good run for any American business, but why did the foundry lay idle and fall into disrepair for the last decade without anyone noticing? Maybe it's simply a part of the American psyche—our throwaway mentality of "use it then toss in the trash." Why would an old industrial building be any different? Forget that it's important to preserve any kind of structure that represents a unique chapter in American history, as the Albany Rolling Mill does. But the real $64,000 dollar question is who's responsible for preserving our heritage—private businesses or the government?

Portec, formerly the Rail Joint Company of New York, owns the Rolling Mill. They purchased it sometime in the early twentieth century to make rail joints and remained in operation here until 1989. There's been a "For Sale" sign on it ever since. Let's face it: the Northeast is not the industrial belt anymore. It's difficult to sell or even lease a building that was made to roll iron, unless of course you want to roll iron—fat chance of that. So for a decade the building sat unused and started falling apart. Is it Portec's fault? Is it the city's for not ensuring that the building was kept up to code? Even though they left Troy years ago, Portec has a picture of the *Monitor* on their website with the caption: "Former Troy New York plant manufactured the armor plating for the Civil War's ironclad monitor." Apparently they are still proud of that foundry building.

A few years ago, Dan Wolfe and his Troy Transfer Company obtained a twenty-year lease on the property from Portec. Dan and his twenty-five employees use the property as a waste transfer station. Contractors bring demolition debris to the site, pay a fee and Troy Transfer takes it to the landfill.

The Albany Rolling Mills in its early prominence. The plates for the Civil War ironclad USS *Monitor* were rolled here. *Courtesy of Watervliet Arsenal.*

Unfortunately, since the foundry and surrounding buildings were in disrepair, Dan felt it necessary to dismantle some of the foundry. This is the situation we are in, although he tells me there will be no more demolition at the present time. Parts of the side wings and walls and roof of the foundry have been demolished. The main part of the foundry is still there and you can see the structural members. The front facade is intact for the most part. Troy Transfer put a new roof on an adjacent building. Dan wanted to knock the whole building down but Portec felt differently about it.

There is probably too much of the original building gone now to get historic preservation money to restore it, but the basic foundry building could be rebuilt and reused. Dan said he would even rehabilitate the building for the right tenant.

It still raises the question: who is responsible for preserving our history? Maybe it's all of us? There needs to be a policy in the city that states that our history is important and all steps should be taken to preserve it. This would include a policy that states that any building not in use still needs to be kept in code. That means a good roof, heated and boarded up, or "mothballed," until a new use comes its way. Perhaps an added incentive would be a tax reduction if the building were mothballed properly. If a building owner does not comply, take emergency action to mothball it and put the cost of it on the tax bill of the owner. This has been done in Albany as far back as the seventeenth century

and continues in recent years. When Troy condemns a building and demolishes it, do they not bill the owner?

Why not have a program that encourages mothballing over demolition instead of the city's current program of seek and destroy. Certainly by keeping our historic stock in shape, it will be cheaper in the long run to rehabilitate it. The city let the roof of Proctor's Theater leak for twenty years! It will never see entertainment purposes again because of the cost to repair it. Vacant buildings do come back to life. Most downtown buildings in Troy have seen that happen more than once. Imagine what the corner of River and First Streets would look like now if the Rice Building was permanently lost, instead of being the jewel it is now? So, the answer is that all of us have a responsibility to save our local history, but it must become part of a collective mindset of all Trojans to make it happen. Every fool knows you can't save every building, but it doesn't stop a wise person from trying.

In the meantime, the remaining part of the foundry building burned and all that stands is the facade. Lesson learned?

# PART III
# INDUSTRIOUS TROJANS

# CAST IRON LEAVES LASTING IMPRESSIONS

I'm stuck on Troy's architecture and I mean that literally! When I was a boy growing up in Troy, I often carried a magnet around with me as I explored the city streets. I would toss the magnet on certain buildings and it would stick to some of them. Often it stuck so hard that it was difficult prying the magnet off. Understandably, the owners of these buildings didn't appreciate it and chased me down the street. But it fascinated me and I often returned, much to their displeasure I'm sure. I remember saying to myself that someday I would know why my magnet stuck to those buildings.

Many years later, in 1977, I decided to get to the bottom of this and spent a year surveying the Capital District. I found more than six hundred "magnetized" buildings. They're known in the vernacular as cast-iron storefronts and they do more than hold up a building's front or facade. Some historians have given these iron artifacts credit for the development of commercial business centers in the second half of the nineteenth century. Others have given cast iron credit for the origin of tall buildings and skyscrapers. Both are correct.

Using cast iron for architectural purposes appeared early in the nineteenth century in England and America, but really caught on during the second half of the century. Some historians have even called the nineteenth century the "Age of Ferromania." It seems almost everything was made out of cast or wrought iron—even toothpicks (for wooden teeth?).

Cast iron is very strong under pressure. This made it possible to make slim columns that could hold up the weight of a building. It was useful not only for commercial buildings but for factories as well, since it allowed the creation of large, open workspaces.

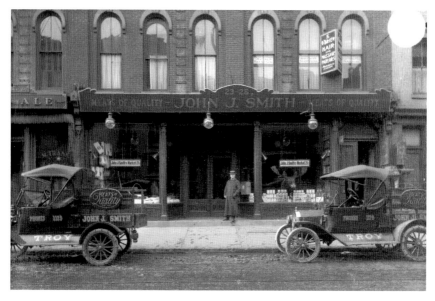

Here can be seen John J. Smith, butcher, showing his cars and storefront on an unknown street in Troy. There were hundreds of businesspeople that called Troy home during the nineteenth century. *Courtesy of Tom Clement.*

The iron was "cast" in molds, so you could produce elaborate, ornate designs with repeating patterns, often resembling more expensive fronts made from hand-carved stone. However, unlike stone or wood, which reacted to the elements, or needed repainting often, one coat of paint on a cast-iron storefront would last a long time and looked "new" for years. The iron was pretty resistant to corrosion once it was covered.

Cast iron was often less expensive to make since one wooden pattern (mold) could produce several castings. Erecting a cast-iron storefront or facade was quick, saving in labor costs, although it was quite an involved process. A whole facade might consist of several hundred individually cast pieces. The foundry men would bolt together the entire facade on the foundry floor, ground pieces to fit, take it apart again and then escort it over to the waiting building and bolt it back up.

Most cast-iron storefronts were only one story. A simple lintel and one or two posts would suffice for a small business. This allowed the first floor to feature large spans of glass, allowing natural light to enter the store (in contrast to dim gas lighting). This encouraged the retailer to put new wares in the window for the shopper to see. Now you know how window-shopping originated. Later, whole facades of cast iron became commonplace (New York City's SoHo district is famous for them).

The cast-iron period lasted for almost one hundred years, ending around World War II. Originally, Albany and Troy became famous for casting iron stoves, but several iron foundries in the area specialized in making cast-iron storefronts: Michael Mahoney's Troy architectural Iron Works (now Lusco's Paper on Fifth Avenue); Starbuck Brothers on Center Island (where the oil tanks are); Torrance Iron Foundry in Green Island; West Side Foundry in Watervliet; and James McKinney in Albany. All were known for quality foundry work. Foundries often placed a "maker's mark" on the bottom of one of the columns as self-promotion and these can often be used to help date the building.

There are several reasons why Troy became successful in the iron industry. As they say in real estate, it's location, location, location. Troy was at the center of the receiving end. It had easy access to all the natural resources that were required to do the job. Iron ores from the Adirondacks were shipped down the Champlain Canal to Waterford and West Troy (Watervliet). Charcoal for heating the furnaces came from the charcoal maker, or collier, from the hill towns of Rensselaer County. Limestone for flux came from the Helderburg Mountains in Albany County. Excellent moulding sand, the main crucial ingredient for casting, came from Albany's Pine Bush area and other parts of the Hudson Valley Sand Belt. In fact, our moulding sand was the envy of every iron-producing region in the country. Finished goods easily found their way west on the Erie Canal, or south to New York City and beyond.

There are many surviving examples of cast-iron storefronts in Troy, some plain and utilitarian. A few are very ornate. There appears to be only one complete cast-iron facade left. Can you find it?

Fortunately, in downtown Troy, many structures are in the process of being renovated, or have been. Many have restored the cast-iron storefronts that were buried under the late-twentieth-century "garbage" facades that were piled over them. Not only do the buildings look great, but it also shows off the skill of our nineteenth- and early-twentieth-century ironworkers.

I know what you're thinking. You can buy a magnet at a local Radio Shack. So, have fun exploring for cast-iron storefronts, but if the owner chases you down the street, don't tell him it was my idea.

## PUBLIC MARKETS OFFERED MORE THAN FOOD!

I used to visit Boston every weekend for a couple of years and always stopped at the public market near Faneuil Hall. It was one highlight of my trip, especially watching the interaction of shoppers and keepers haggling over prices. I always

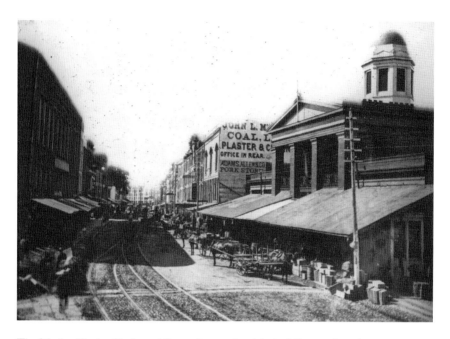

The Market Block with the public market on the right in full operation about 1900, looking south down River Street. The city built three public markets for its citizens. This one burned down and was replaced by a city bank. *Courtesy of the author.*

filled up the car with an assortment of vegetables that would last until the next weekend trip.

I also enjoyed seeing the same faces every weekend behind the vegetable wagons and the sounds of the market men shouting in that unmistakable Boston accent: "Get your lettuce here," or "Want to buy some meat?" Those familiar faces made me feel comfortable being there away from home. After a month or so, many of the producers recognized me and took me aside, making sure I had the best pickings of the day. As one butcher told me, "A happy customer becomes a regular customer."

It wasn't long ago that most cities had public markets in their downtown. You would go for vegetables, primarily during the summer and fall, then to the local butcher for your meat, although butchers were also at the markets. Milk and eggs were delivered to your door by the milkman, and local bread by Frehiehofers. Mom and pop corner grocery stores tried to accommodate the rest of the year.

The growth of supermarkets in the '50s and '60s put most out of business as people demanded more convenience in the form of prepared foods (aka, frozen dinners), or one-stop shopping for all items (aspirin, beer and diapers with those eggs).

Troy is no exception. At one time, there were three public market houses built by the city for its citizens. None exist today. According to historian Rutherford Haynor, those early markets were more than a place to get food but also were part of a larger social event. Housewives met their friends or formed small groups and shared rumors and news. The buildings became a focal point for public forums by politicians, and religious meetings were held. Even concerts and plays were performed on the second floor above the fish, fruit and veggies.

The first public market opened in Troy in March 1800, and was a wooden building twenty feet wide by sixty feet long. It sat in the middle of State Street between First and Second Streets. On the north and south sides of the building, underneath the overhanging roof, the Premier Engine Company, Troy's first fire department, hung their fire ladders and hooks, conveniently located in case of fire. This market served residents until 1806, when the village trustees sold it for fifty dollars.

That year the city purchased land on the northwest corner of Third and State and built a new public market. It was known as Center Market, often referred to as "Cow Place," and another building was added to it in 1828. The solid building facing Third Street was used as a meat market while the open-air building on the north side of State Street was used for selling fish, vegetables, butter and eggs. In 1860, the Arba Read firehouse was built on the site; a Fleet bank building is there now.

In 1812, the village trustees established two more markets.

North Market was built on the south side of Federal Street in 1828. The next year the second floor was dubbed the Troy Theatre and opened on July 4 with a play called *Pizarro, or the Death of Rollo*. It was replaced by the Eagle Engine Company No. 10 firehouse built on the site in the 1840s.

A house was built for the South Market in 1828 on the northeast corner of Division and Second Streets, but in August 1839, the city purchased two lots on the southwest corner, opposite the existing one. They erected a brick building, named it Washington Market, and it opened in May 1841. The second floor of this market was also converted into a theatre.

In 1840, the city took the Troy Shipyard at the junction of River and Fulton Streets, earlier donated by Jacob Vanderheyden, and erected a brick building in Greek Revival style at a cost of $30,000. The first floor was rented to butchers and market men, and the large area on the second floor was used as a concert and lecture hall. Fulton Market opened in May 1841, at the same time as Washington Market. In February 1847, the hall on the second floor was turned into a theatre and opened with the play *The Lady of Lyons*, on Washington's Birthday. It burned down in February 1903.

Even as public markets fell out of use, Trojans (the Women's Civic League in particular) tried to revive them during the first quarter of this century.

In 1910, the city developed a marketplace around Washington and Hill Streets and leased it to the Market Grower's Association, which lasted into the 1950s.

We need to bring back a public market to Troy. Presently, there is a farmer's market that meets outside the Atrium on Broadway between Third and Fourth Streets from May to October. A few local farmers bring their harvest down from the hill towns of Albany and Rensselaer Counties.

A large regional public market would be ideal and would bring in thousands of people to the city, especially if it were held on a weekend with festivals, concerts and other activities. Many of the downtown businesses would also profit from the increased people traffic.

But where would you place a large public market that wouldn't cause a traffic problem? Certainly the city cannot afford to build a market building like they did in the last century.

Next to the band shell along by the river and across from the parking garage would work, although you would have to divert traffic along that corridor from the bridge to the intersection of River, Fulton and Third Streets. Why not take the section of Fulton Street from Third to Fourth, close it to traffic, and set up there along the side of the parking garage? There are no businesses along that route anyway.

The parking lot adjacent to the former Cluett Peabody factory is ideal (with John Hedley's permission) and it's also the site of the boat landing so that could entice boaters to come up from the city.

What about Prospect Park? It certainly would bring people back to the park and you could have barbecues right there using the fresh items that you just purchased.

Any other suggestions?

*Note:* Since I wrote this material in 1999, a very successful public market opened weekly at Hedley's on the riverfront and currently meets every Saturday in the Atrium. It is one of the most successful and popular farmer's markets in the Capital District.

## THE END OF A ROLLING ERA

When the Albany Iron Works (or as it was known in recent times, Portec Rail Products, Inc.) closed its doors in 1989, it not only ended the life of a historic rolling mill, but quietly disbanded a family of workers representing some 150 years of solidarity.

David Fogarty and Frank Scorsone know it well since between the two of them they worked there for almost thirty years.

Fogarty worked at Portec for fourteen years. He was the plant manager when Portec ceased all operations in Troy. Dave began work in 1975, at the age of twenty-two, working as a machine operator and worked his way up to become manager in 1987, two years before the mill closed. Frank, who began working there at age twenty, also in 1975, was the "relief man on the hot line." In essence, he performed all the jobs from cutting rail, punching holes for bolts, stamping the rail and whatever else was needed to do while a fellow worker took his break.

According to Portec's website, the company makes

> *rail lubrication and friction management systems for hi-rail, on-board and wayside application as well as insulated rail joints, rail anchors and other track accessories. In addition, Portec Rail Products Inc. offers a complete line of rolling stock products that include intermodal container locks, auto rack bridge plate, heavy equipment tie-downs and other load securement devices, locomotive drop tables, freight car jacking systems and mobile intermodal car jacks.*

Here in Troy, Dave, Frank and the other workers fabricated rail joints. These are splicing bars that hold the ends of two rails together. They brought in raw material in the form of used railroad car axles or billet steel from the Auburn rolling mill then took the iron, heated it up, hot formed and shaped it in a forging process. It's ironic that the foundry's last use was as a forge, since the first industrial site at that location was the Star Forge that later was incorporated into the Albany Iron Works. They also made bonded rails (two rails bonded together) and even made the tracks for StoryTown's (Great Escape) train ride. It was particularly hard work in the summer from the heat of the furnace (no air conditioning) to freezing in the winter (no heat unless you stood by the furnace). A mandatory twelve hours a day four days a week, ten hours on Friday and eight on Saturday made for a long week. During winter months, almost everyone wore a beard to keep warm.

There were between 145 and 189 men that worked for Portec and they all knew the history of the foundry, in particular the rolling of the plates for the USS *Monitor*. In fact, it was Dave that donated the remaining two hull plates to the Hudson Mohawk Industrial Gateway. The plates were found when they were renovating a storeroom. You can view them now on exhibit at the Burden Museum off of Polk Street. There were actually a few plates found but some were cut up in pieces and given to various people as gifts as well as to

Industries like Ludlow Valve here in 1899 were important players in the development of Troy as a major iron and steel city up to the twentieth century. Most of these industrial buildings are gone, due to neglect, fire or demolition. *Courtesy of the Schenectady Museum.*

Rensselaer town historians. Sand Lake Town Historian Judy Rowe has a small piece hanging in her office. Frank has a piece at home. Before the rescued plates were donated permanently to the Gateway, they were loaned for exhibits at the New York State Museum and in Philadelphia.

Fortunately, the workers received a severance package and Dave, Frank and about ten other former employees found work in Green Island's Norton Saint-Gobain Company, which makes sandpaper. While there are no reunions from the workers of the Albany Iron Works, many still talk to each other and fraternize, since most were local South Troy and Watervliet residents. Frank retired from Norton after thirteen years and is a short order cook for the Famous Lunch. Dave still works at Norton. On October 31, 1989, the day of the mill's final closing, there were many tears shed, but Frank and Dave told me that everyone would go back to work there in an instant. There was a real bond between the workers and they loved working at the mill. All that remains now is a photo taken of all the workers together for the last time—itself historic by the very nature that it represents an end of an era.

Unfortunately, the foundry building burned to the ground a few years ago. Recently, the Rensselaer Rolling Mill also burned to the ground, after much fanfare about its upcoming restoration.

# TROY'S HISTORY RINGS LOUDLY

For thousands of years, bells have served in various capacities in most civilized cultures. They have been used to signal time, human passings or natural disasters. Bells have been used to communicate, or played as musical instruments. They have been part of the rituals of religious institutions for centuries. Even today, many ancient Chinese bells, some more than three thousand years old, remain artifacts that still function from the time of the Shang and Zhou Dynasties.

While bells have been part of humanity's toolbox, some of the finest-sounding bells were cast right here in Troy and across the river at West Troy (Watervliet) during the nineteenth and twentieth centuries. Thousands of Troy bells still grace church towers and other institutions around the world. Troy bells are known for their quality of sound and workmanship. Yet, this local industry that served the world comprised no more than four companies and was pretty much a family affair: the Mannerly family (two different companies); Julius Hanks; and Jones and Company.

Troy's first bell caster, Julius Hanks, was the son of Benjamin Hanks, who built the first bell foundry in America. Julius moved his manufactory of scientific instruments from Watervliet (then Gibbonsville) to the corner of Fifth and Fulton in Troy in 1825. Besides church bells, Hanks began to make town clocks and surveyor's instruments. One of Hanks's employees, William Gurley, a graduate from RPI (then called Rensselaer Institute), later established on the same site a manufacturing company that produced surveyor's instruments that became famous for their engineering and quality. The Gurley Building still stands at this location.

When Hanks operated his foundry in Gibbonsville, Andrew Meneely, the son of Irish immigrants, became an apprentice, learned the trade and later purchased the foundry after Hanks moved to Troy. Andrew also married the niece of Julius Hanks's cousin Horatio. Meneely's sons George and Edwin took over the business in 1851 when Andrew died.

The Meneely brothers gained a reputation for excellent quality and George was awarded a patent for a method of attaching bells to a yoke that permitted the bell to turn, allowing the clapper to hit all parts of the bell, instead of one spot, thereby avoiding the chance of cracking like the Liberty Bell.

The Jones Bell Foundry was a premier Troy company that made many bells that still ring today. *Courtesy of the Rensselaer County Historical Society.*

A brother-in-law of Andrew Meneely, James Harvey Hitchcock, left the employ and along with Eber Jones created a competing bell company, Jones and Hitchcock, later Jones and Company, in 1852. While they gave Meneely a run for his money, they went out of business only thirty-five years later. One of their last castings was the tower bell that was placed in old city hall on the corner of Third and State Streets.

A third son of Andrew Meneely, Clinton Hanks Meneely, entered the bell-making business in Troy with George H. Kimberley on River and Adams Streets directly across the river from his brothers. This created a feud that lasted for years, including a court case to force Clinton not to use the Mannerly name. The West Troy Meneelys lost the case.

Both Meneelys produced thousands of bells, over 350 chimes (8 or more bells) and a few carillons (23 or more bells) until they both went out of business in the early 1950s. Their bells still ring, however!

According to Joe Connors, a chime historian who not only can play them but also has videotaped many, the surviving chimes located in Troy churches were made by both Meneely foundries.

Holy Cross Episcopal (only six bells), Woodside Presbyterian (key of G), Ascension Episcopal (key of G) and St. John's Episcopal (probably F or G originally) have sets cast by the Meneelys of West Troy.

St. John's Episcopal (West Troy bells replaced in 1911 by Clinton's in E Flat—no one knows why), St. Peter's (E Flat), St. Joseph's (E Flat) and St. Patrick's Roman Catholic (E Flat) churches all have chimes cast by Clinton Meneely of Troy.

P. Thomas Carroll, executive director of the Hudson Mohawk Industrial Gateway, reports that close to fifty to a hundred-thousand bells were produced in this area and most are probably still out there. And according to Connors, almost 70 percent of the chimes made in the country were made by the two Meneely and Jones bell makers, making this area the premier bell-casting region in the country.

Interestingly, the Meneely foundries had other differences—the actual tone of their bells. According to Musicologist Dis Maley Jr., who has perfect pitch and has listened to many of the local bells, Andrew Meneely's bells seemed to have been tuned to the keys of F or G, while Clinton Meneely's bells were tuned to the key of E Flat. Whether this holds true for all the bells cast by these two foundries will make a good research project.

Maley also says that the Clinton bells were heavier, sounding stronger, but have undertones in the higher bells. Clinton apparently cast his bells exactly to specifications but did not tune them afterward.

Andrew's bells, which were lighter after 1922, would be tuned after casting if they were off-key. According to Maley, this gives Andrew's bells a bit more of a musical quality than Clinton's. Whether this tonal difference was done on purpose—Clinton trying to differentiate his from his brothers—is unknown and worthy of further study.

P. Thomas Carroll of the Gateway would have liked to have seen all of the existing Meneely bells in the area ring at the same time, on the 200th anniversary of Andrew Meneely's birthday in 2002, or perhaps, more fitting, on the birthday of Julius Hanks, the first bell maker of Troy.

The Gateway was given a one-ton West Troy Meneely Bell from Senator Joseph Bruno and is now looking for a suitable place to house the bell so the public can have a chance to see it and ring it on special occasions. Where do you think the bell should be housed? Personally, I would like to see it in front of city hall, next to the Visitors Center, with a nice plaque that describes the bell industry of Troy.

## GETTING TROY ON TRACK AGAIN!

I had a special fascination with railroads when I was growing up in Troy. Not surprising, since trains ran right through the heart of the city several times a day. All but a few reminders of Troy's glorious railroad history survive. Most of it has been destroyed and taken away.

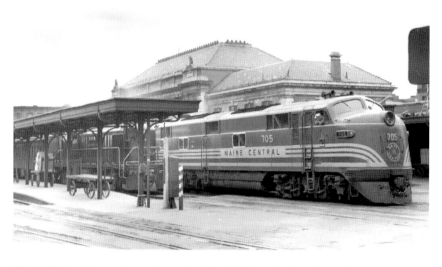

The "705," getting ready to roll north at Troy's Union Station, located between Fulton Street and Broadway. Union Station was torn down for a parking lot in the 1950s, a sign of things to come. *Courtesy of Jim Shaughnessy.*

The block around Union, Broadway, Fulton and Sixth Avenue was Troy's railroad hub in the form of the Union Railroad Station. The station was controlled and owned by the Rensselaer & Saratoga, Troy & Schenectady, Troy & Greenbush and Troy & Boston Railroads. Built in 1854, it burned in the great fire of 1862, but was immediately rebuilt. In 1903, a new Beaux Arts–style station took its place and lasted until 1958, when it was replaced by a parking lot.

Trains entered Troy from Rensselaer, Green Island and from the Northern states. They crossed into the city in South Troy, starting at Madison and headed northeast until reaching the Market Block at Liberty. From there, the trains went into a small tunnel under Fifth Avenue, then hugged Mount Ida until they went through the Ferry Street Tunnel, exiting at Congress, and reaching the station a few feet from there. I can now confess after all these years that I threw stones into the coal cars as they exited or entered the tunnel from Congress. We also played "chicken" with the trains in the tunnel.

Trains also rumbled over the Green Island Bridge with the tracks splitting south into the train station, or north to the rail yards at Middleburgh and beyond. You can view the track right-aways past the bridge at a set of buildings along Fifth Avenue and Grand Street (look for the angled buildings).

I remember waiting for the trains to cross the street while sitting in my father's '53 Desoto. Every street and alley crossed by a train had a small shanty

and a railroad man who would come out and stand in the street with a large sign pole (probably a stop sign, but I can't remember). I do remember sitting there with my father counting the cars and it wasn't rare that long trains near the station would be backed up, blocking Broadway. Pedestrians simply climbed up and through the cars to the other side.

I really loved that train station. While only a block long, the inside seemed gigantic, with a large central hall with a grand ceiling and huge windows. The ticket window was to the west (Union Street). To enter the trains, you exited through doors on the east; a large clock above told you the departure time. That clock was recently auctioned by an antiques dealer in New York. If you were headed north, you climbed downstairs and entered a subway tunnel that looked like a Greek temple and exited on the other side of Sixth Avenue.

Outside, you were shielded by the elements by a long overhanging platform, which by the way is now used as a tee off at Hoffman's Driving Range.

Several wings were attached to the station. One of those wings was used by the Railroad Express Agency (REA). My uncle Boyd had the franchise and my father worked for him. Each day hundreds of mailbags were taken off the train cars and loaded onto trucks and driven to the post office a block away. Other bags would be driven to the Albany Airport—at that time it had no more than two runways. I liked helping my dad because I (and my friend Paul) would get to sit in the back of the truck, in the dark, amidst all the mailbags and have a ball on the way to the airport. You'd be surprised how many tunnels you can create. After a hard day of work, dad would take us to Torniesello's across from the station for ice cream sundaes.

Troy's rail days were impressive. In the early teens, there were 130 passenger trains a day (one every eleven minutes) going through the city. There were more than 30 trains running daily between Troy and Albany, twenty-five minutes apart on the commuter "Beltway." In fact, in 1954, you could go from Troy to Albany, hopping on a daily New York Central starting from the main station, or at stops at Adams, Madison or the Iron Works near Polk.

If you want to relive Troy in the '50s, the RPI Rensselaer Railroad Heritage Club has a great model of Troy with running trains, videos and more. Contact them at http://railroad.union.rpi.edu/index.php.

It's rumored that Amtrak might build a new passenger train station in Troy, and there are efforts to create a new light rail system in the area. In my opinion, it can't happen soon enough.

# PART IV
# TROY AND SCIENCE

# LOCAL SCIENTISTS HAD WORLD IMPACT

Troy is the birthplace of American geology, but there's more to the story. In fact, two of today's largest scientific organizations in the world have roots here in the Capital District, founded by local scientists.

The name Powers is well known in Lansingburgh. William Powers, a former schoolteacher, started a successful oilcloth factory on Second Avenue in 1817. After a freak accident took his life, his wife Deborah and his two sons Albert and Nathaniel carried on the business. They became one of the leading business families in the village, operating a bank and an opera house and helped fund schools and gave to the needy.

In 1862, Albert had a son, A.W. At the age of twenty-two, A.W. married Matilda Wheeler Page in 1884. They had one son, Sidney, born in 1890.

Sidney Powers is one of the most respected names in American geology today. Powers attended school in Troy and at the age of twenty-one earned his BA in geology from nearby Williams College. Powers's early work in Oklahoma was a major event in the evolution of the field of petroleum geology and the oil industry.

At the time, most oil searching was done by looking at hills and valleys, mostly a surficial geology approach. Powers promoted the importance of looking underground instead and this led to the beginning of the use of drill cuttings and geophysical prospecting, according to Dr. Gerald Friedman from the Northeastern Science Foundation.

During his short lifetime, Powers published 124 articles that explained how to use geology to find oil and are still used today around the world. Powers was a founding father of the American Association of Petroleum Geologists (AAPG), today the largest geological society in the world. In fact, the Sidney

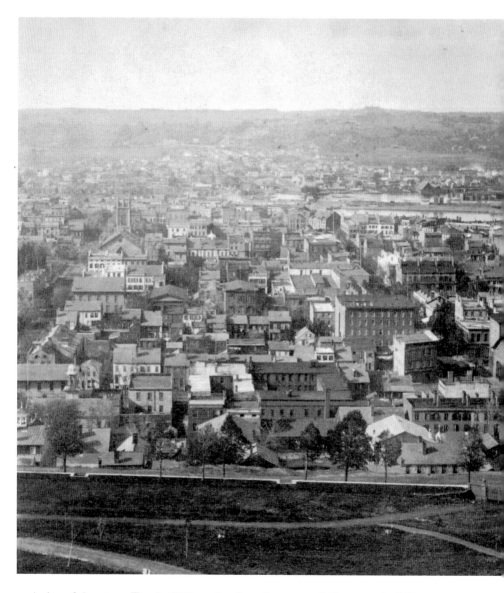

A view of downtown Troy in 1861 as taken from the towers of Troy, now the RPI campus. *Courtesy of the Library of Congress.*

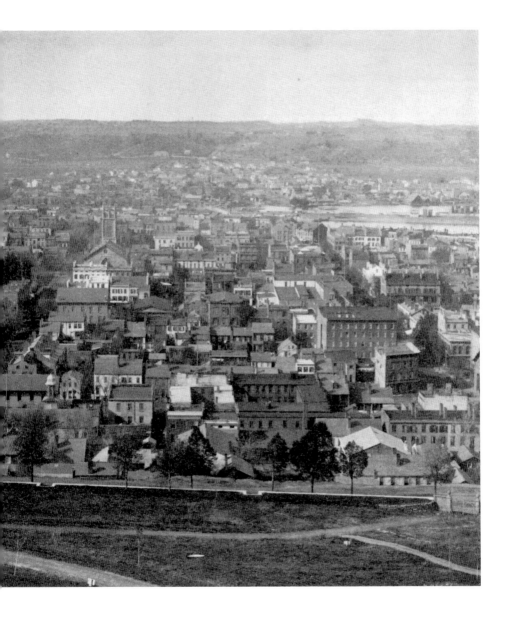

Powers Medal is the AAPG's most prestigious honor. Powers died in 1932 and is buried at Oakwood Cemetery.

Across the river in Albany, Joseph Henry was born in 1797 and lived at 105 Columbia Street, not far from city hall. Henry is the inventor of the electric motor, is called the father of daily weather forecasts (he established six hundred observation stations around the country in two years) and was the first head of the Smithsonian Institution (in 1846).

Joseph Henry taught at the Boys Academy next to his home and discovered a way to transmit sound over wire by magnetic force (the telegraph) in 1832. His friend was S.F.B. Morse, who went on to perfect the Morse Code and get credit for the telegraph. Henry also was a big supporter of Alexander Graham Bell in his invention of the telephone.

Henry was a founding member of the American Association for the Advancement of Science in 1848 (and later president). The AAAS was the first permanent organization formed to promote the development of science and engineering at the national level representing all disciplines (today the largest scientific organization in the United States). By the way, Almira Phelps, a science writer from Troy, New York, was one of the first female members (joined prior to 1860).

The 1856 AAAS meeting was held in Albany and was organized by New York State Geologist and AAAS president James Hall, "Father of American paleontology." It involved the dedication of two major scientific facilities in Albany—the New York State Geological Museum (now the New York State Museum) and the Dudley Observatory, both still in existence. Hall also presented his famous paper on the theory of "geosynclines."

Joseph Henry was also one of the original members of a group that later became the National Academy of Sciences in 1863, and served as its second president.

When Henry died on May 16, 1878, the entire federal government closed. His funeral was attended by the president, vice president, members of the cabinet, Supreme Court judges, members of Congress and others. Henry was one of the most respected scientists in the country. In 1883, the government closed again to dedicate a statue in his honor.

James Eights, born on North Pearl Street, was an Albany physician who never practiced medicine. Instead he became the first American naturalist to visit and study the Antarctic on a quasi government-backed expedition organized by Edmund Fanning. This "Voyage of Discovery" sailed from Connecticut ports for the South Seas in October 1829. Eights wrote the first geological and botanical description of parts of the Antarctic area. He explored Patagonia, Deception and Staaten Islands, Tierra Del Feugo and the South Shetland Islands.

He also discovered three new species of crustacea and won scientific praise.

Locally, Eights is known as an artist who painted early Albany street scenes but his geological work is praised in scientific circles. Eights studied under Troy's Amos Eaton, the "Father of American geology," and participated in Eaton's floating school in the Erie Canal. Eights produced a number of maps and etchings that have been widely reproduced around the world. These were among the first illustrations ever produced.

Eights was later appointed to go on the first government-sanctioned Wilkes Expedition back to Antarctica in 1838, but was bumped.

He spent the rest of his life writing and popularizing science in local magazines and journals. He briefly left the area and was a geologist in North Carolina in the 1850s. But his major contributions, which still are praised, concern his work in the Antarctic. Locally, his work in describing the natural history of the Albany Pine Bush in 1836 in his *Every Day Naturalist Book* was instrumental in showing the negative impacts that development has had on the region today.

Eights died in 1882, at the age of eighty-four in Ballston Spa.

These three local men had a profound influence on the early development of science in this country and their contributions are still recognized by the scientific community today.

## TROY—BIRTHPLACE OF AMERICAN GEOLOGY?

Before 1830, there were two important centers for the study of the science of geology. London, the largest city in the world at that time, and Troy, New York, with a population of a little more than ten thousand. In fact, before 1818, there was little published at all about American geology.

While Troy is better known as the birthplace of the American Industrial Revolution, among the scientific community the city is known as the birthplace of the study of geological science in America.

Two people are given credit for this honor—Stephen Van Rensselaer (1764–1839) and Amos Eaton (1776–1842).

Stephen Van Rensselaer, descendant of the original Dutch Patroon, graduated from Harvard in 1782. In 1819, the New York legislature hired him to preside as president of the Central Board of Agriculture. Under the auspices of the board, two volumes were published (at his own expense) on the geology of Albany and Rennselaer Counties and were authored by Amos Eaton, a Columbia County native who was originally trained as a lawyer. According to historians of geology, it was the first attempt in America to collect and arrange geological facts for the betterment of agriculture.

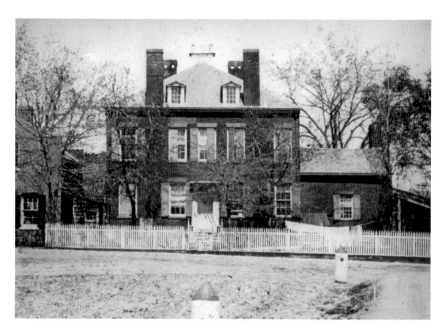

The Farmer's Bank at the corner of Middleburgh and River Streets was the first home of Amos Eaton's Rensselaer School, now Rensselaer Polytechnic Institute, the first science school in America. Eaton lived here as well. *Courtesy of Watervliet Arsenal.*

Amos Eaton had earlier conducted a geological survey in Massachusetts, which is the first recorded instance of the American use of a field trip as a tool of study, which would later become the accepted way to train in public schools and colleges up to this day. Also, in 1818, Eaton published a textbook with a time and rock classification system, and a local field guide that may have been one of the first in the country. But Eaton's glory really began when he teamed up with Van Rensselaer.

Van Rensselaer supported Eaton's geological study of the land adjoining the newly formed Erie Canal during 1823–24. This survey revolutionized geology and other sciences through its introduction of new and precise nomenclature for the rocks of the state, according to Dr. Gerald M. Friedman from the City University of New York, the author of several papers on the history of American geology.

In 1824, Eaton asked Van Rensselaer for $300 to start the Rensselaer School (now RPI), a school he eagerly founded and financially supported until 1829. By 1830, Eaton, founder and first professor of the school, had published a textbook and geologic map of the entire state but also was making an enormous impact by becoming the mentor of several students that would later contribute enormously to the geologic knowledge of the country.

Rensselaer Polytechnic Institute was located here between Seventh and Eighth Streets until the building burned down. At this location the school built the "Approach," a classical stairway that connected the school to the city. *Courtesy of the Rensselaer County Historical Society.*

In fact, the geological profession describes the period 1818–36 as the "Eatonian Era," in honor of the success of Eaton's promotion of geology during that time. By 1860, seven graduates of Eaton's school were in charge of geological surveys throughout the country, a feat unmatched by any university to this day.

Many of Eaton's students went on to their own fame—James Hall, Ebenezer Emmons Sr., James Eights, Lewis Beck and Joseph Henry, to name a few.

Joseph Henry, one of the students on Eaton's flotilla down in the Erie Canal, was the first secretary of the Smithsonian Institution.

James Eights, an Albany doctor and naturalist, became the first American naturalist to explore the Antarctic (and locally kept a daily diary on the natural history of Albany's famed Pine Bush).

James Hall was known as the father of the geosyncline, a geological concept that lasted one hundred years (and is not even mentioned in textbooks now). Hall was appointed New York State's first state geologist in 1836. He was considered the father of paleontology.

Lewis C. Beck (an M.D. from Albany Medical College), from Schenectady, was appointed the first junior professor at RPI under Emmons. In 1829, he became New York's state mineralogist. That year his brother, T. Romeyn Beck,

and Governor William L. Marcy (another Troy native), appointed Lewis Beck to survey the state's mineral resources. By 1842, he had traveled over eight thousand miles and published one of the classic volumes of the New York State Geological Survey.

Ebenezer Emmons Sr. became junior professor at Rensselaer in 1830 and stayed there for ten years. He became the state geologist for the northern New York State district in 1836. Emmons is the person who named the Adirondacks (1838) and Taconic Mountains (1844). He later became the state geologist for North Carolina, and throughout his career published several classic geology texts in 1826, 1842, 1854 and 1860.

Emmons had a well-publicized falling-out with James Hall and others over Emmons's Taconic System Classification, and was blackballed from New York State intellectual society. He sued Hall for slander and libel but lost the case. He did get his revenge, though. After he died in 1863, his body was returned to the area and was buried in Albany Rural Cemetery, just a few feet from Hall. I've been told he was buried facing Hall!

Amos Eaton, whom some call the father of American geology, died in 1842 and is buried in Oakwood Cemetery.

## TROY SCIENTIST RECOGNIZED

Silas Watson Ford is a name that doesn't come up often in the annals of American geology, but that changed with the publication of a paper by paleontologist Linda VanAller Hernick of the New York State Geological Survey.

Hernick's research on Ford, a Troy telegrapher, has elevated him to a position that he long deserves, as a paleontologist who made some of the most important discoveries regarding Cambrian paleontology in the nineteenth century. He found the first early–Cambrian period fossils in North America, helping to resolve a geological controversy that had lasted for thirty years. In his short life span, Ford published more than twenty-three scientific papers. His seven-part series of geological processes in the *New York Tribune* in 1879 was so popular that Union College in Schenectady awarded him an honorary master's degree.

The Ford family was originally from Glenville, New York. Silas and his family moved to Schenectady after the death of his parents, and then to Troy. His brother, Stephen Van Rensselaer Ford, went from station agent for the Rensselaer & Saratoga Railroad (in 1854) to a joint partnership with George P. Ide (in 1865) to make collars and cuffs. Ide and Ford located their business at 506 Fulton Street.

Silas appears to have moved to Troy the following year, boarding at 208 North Second Street, and was listed as a telegraph operator. His brother Isaac was a telegraph operator at the Union Railroad depot and probably trained his younger brother. Later, he is listed as a bookkeeper and may have worked at Stephen's collar company. The partnership between Ford and Ide dissolved, and George Ide went on to run one of Troy's largest collar companies. Silas went back to work as a telegraph operator but his keen interest in geology finally led him to James Hall, the state geologist in Albany.

Hall and fellow geologist Ebenezer Emmons were engaged in an intellectual battle. Emmons had proposed the Taconic System to describe the formation of the Taconic Mountains and rocks of easternmost New York and western Massachusetts. Emmons had given an older Cambrian age (540 to 505 million years ago) to these rocks, while Hall said they were younger, of Ordovician age (500 to 438 million years ago). The Taconic Orogeny or mountain-building period happened about 450 million years ago, when a volcanic island arc collided with proto–North America (around the Connecticut Valley region). This event ran from Newfoundland to Alabama. The rocks, which had

A photo assemblage of trilobites from one of S.W. Ford's specimen collections in the New York State Museum. Ford's little paper arrows point to examples of *Ollenellus asaphoides* and *Serrodiscus speciosus*. They are Lower Cambrian in age and were collected in Troy. This is a close-up photo as the fossils themselves are less than one centimeter in diameter. *Courtesy of Linda Hernick, New York State Museum Paleontology Collections.*

originally been deposited in a deep-water area, were stacked together by these plate collisions and formed the Taconic Mountain Range. Originally this mountain range was as high as the Himalayas, but quickly eroded and the sediments were deposited into a shallow sea that covered most of the middle half of proto–North America.

In Troy you can see this overthrust, where older rocks are sitting on top of younger rocks (especially in the Mount Ida Gorge); geologists have attempted to explain this anomaly (now called the Emmons Thrust, earlier Logan's Fault). Ford had found fossils in parts of these rocks in Beman Park that helped explain the older age of the rocks and in the long run helped support Emmons's theories. Eventually Emmons was proven correct.

Ford jumped into the fray. His discoveries of fossils of Cambrian age proved that portions of the Taconic were older than what Hall had proposed. While not formally trained in geology, he wrote to Hall early on, at the urging of William Gurly, in an attempt to get help and guidance in training in geology, his real passion. Ford had offered loans of his fossils to Hall and Hall visited Ford in Troy. In 1871, Ford published an important article in the *American Journal of Science* that correlated the Troy rocks to the older Cambrian period and described the first-ever fossil found in North America, *Hyolithes opercula*. At twenty-three, this established Ford as a leading authority on Cambrian fauna east of the Hudson. He even had one of his fossils named after him by a leading paleontologist in 1881. *Fordilla troyensis* is one of the oldest know bivalves in the world. Throughout all of this, he was still a telegraph operator working for the American Telegraph Company, then absorbed into Western Union at 249 River Street, where city hall is located today.

What appeared to be a promising career, however, came to an early end. He temporarily worked with the U.S. Geological Survey, got married and was prolific in his writings. However, as Ms. Hernick points out, Ford had either an alcohol or opium addiction and always seemed to be in debt, needing to borrow money. Eventually most of the geologists he had been corresponding with or working with wrote him off. Ford had a $72.20 debt that he couldn't afford to pay off.

Separated from his wife, she tried to sell off his fossil collection of 419 specimens and a 170-volume personal library to repay the debt. Ford himself had been declared legally incompetent, so Mrs. Ford assumed all liability for the debt. James Hall tried to get the state regents to buy the fossil collection but problems arose and continued to occur—they agreed to buy it but then reneged on the deal. While the state bickered back and forth, Mrs. Ford died on February 24, 1895. The collection was finally purchased (no one knows who the seller was)

in 1900 for $70.70 and is now in the state paleontology collections. No one knows what happened to Ford's personal library. Ms. Hernick believes the great Capitol fire of 1911—in which almost half a million of the state library's collections were lost–may have consumed them.

Four months after Mrs. Ford died, Silas died at his cousins' home in Wilton on June 25, 1895, and was buried in Schenectady's Vale Cemetery. He was forty-seven.

Regardless of his personal problems and short life, Troy's Silas Watson Ford's twenty-year contributions to American paleontology are well documented and finally given the recognition he deserves, thanks to the research of Albany paleontologist Linda VanAller Hernick.

PART V
# TROY POTPOURRI

# Give Me Your Singles, I'll Sing You a Jingle

I enjoy a good jingle, especially ones that make me laugh. I rarely buy the product, but I like the creative approach of using psychology in marketing. I want to see how far a company will go to get my buck.

Today we are bombarded with commercial advertising. Buildings are named after soda (a Pepsi Arena). School cafeterias sell only one brand of food. I'm surprised there isn't a print ad on birth certificates for newborns. It might go like this:

> *We hope you are pleased with brand new baby Jane, brought to you by the gentle hands of Dr. X at Hometown Hospital. This certificate is good for our special—two deliveries for the price of one. Act fast, it's good for one year only. Void where prohibited. Do not shake. Contents by weight. Some settling may occur.*

As much as we might hate getting hit with all this commercialism, advertising goes farther back in human history than we care to admit.

Historians give credit to the Babylonians as the first people to introduce advertising through the use of store signs and street barkers back in 3000 BC. They're also credited with the marketing ploy called "sponsorships," when they allowed kings to stencil their names on the temples they built. For 3,500 years, advertising techniques didn't change much.

By 1700, colonial postmasters were acting as the first advertising agents, accepting and forwarding ads to various publications.

Throughout the 1830s, traveling patent medicine men combined selling products with entertainment and testimonials. Products were painted with slogans on the sides of the salesmen's wagons.

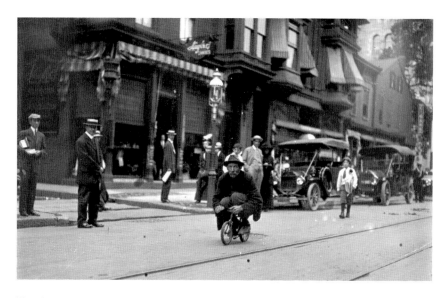

Troy is a city of characters, as proven by this Trojan peddling his way up Broadway. *Courtesy of Tom Clement.*

By 1841, with the Industrial Revolution creating national distribution channels, and with the introduction of a cheap papermaking process from France, newspapers exploded around the country, giving rise to print advertising!

Paper was invented in China in AD 105, although the earliest known daily newssheet *Acta Diurna* (Daily Events) was published in Rome in 59 BC. Yet, it wasn't until AD 1525 that the first print ad appeared in a German news pamphlet. For the next three hundred years, ads in publications were small, similar to our classified section in today's newspapers, mostly because of the scarcity of paper.

Paper really didn't come into its own until the last half of the nineteenth century. Its sudden rise was memorialized in song. "The Age of Paper" was a popular music hall song in the 1860s. The first stanza goes like this:

> *Of "Golden Age" do poets tell,*
> *The "Age of Brass" they laud as well;*
> *While ev'ry age hath serv'd by times*
> *A peg on which to hang their rhymes.*
> *But as the world goes rolling on,*
> *Strange times indeed we've chanced upon,*
> *For Fashions progress never lags-*
> *And now we're in the "Age of Rags."*

# Heritage on the Hudson

*For paper now is all the rage
And nothing else will suit the age.*

The paper boom was a result of the invention of the Fourdrinier machine and the paper pulp process. The Fourdrinier machine allowed paper to be made in long continuous sheets. The previous method of using paper frames limited the size of the sheet (basically to whatever size could be held by the hands of one or two paper-makers).

Before 1850, most paper was made from rags, but with the invention and use of wood pulp, the price of newsprint dropped remarkably. From 1850 to 1900, twenty newspapers were started in Troy alone!

With the explosion of newspapers came the print ad—not that they had to be accurate or truthful, mind you. In the days before government intervention, a product could claim to cure everything under the sun. Did you know that when oil was discovered, they had no idea what to do with it? They sold it as a stomach remedy.

Print advertising was here to stay, regardless of their claims. You can see some of the more interesting nineteenth-century ads that graced the pages of *Harper's Weekly* at http://advertising.harpweek.com.

Advertising did not confine itself to paper or the sides of wagons. It wasn't uncommon to see the sides of buildings painted with advertisements. You can still see remnants on several downtown Troy buildings for Coke, Frears and others.

Print advertising continued to dominate until the invention of radio and television—and the popularity of the dreaded automobile.

In 1920, radio appeared and advertisers quickly followed. The first sponsored program to be broadcast was by the AT&T station WEAF in New York in October 1922. Television was next. In 1945, Lever Brothers signed on for four half-hour shows to be produced on the CBS station in New York, WCBW. Among the national advertisers using TV in 1945 were Bulova Watch Co., Botany Worsted Mills, Pan American World Airways, Firestone Tire & Rubber, RCA Victor, Gillette Safety Razor, Esso gasoline, U.S. Rubber, R.H. Macy & Co. and Alexander Smith & Sons.

Advertising took to the pavement. With the rising popularity of automobiles came construction of thousands of miles of roads. Perhaps one of the most successful advertising gimmicks were the Burma-Shave signs. In 1925, Allan Odell convinced his father to use small, wooden roadside signs to pitch their product, Burma-Shave, a brushless shaving cream. At its peak there were seven thousand signs across America. Three to six signs were placed each a certain distance apart, with each having part of a rhyming jingle. The last one always

said, "Burma-Shave." By 1963, there were none—they were replaced by large billboards. You can read more than one hundred Burma-Shave signs at the Fifties Website (www.fiftiesweb.com/burma.htm).

And that brings us back to the jingles. Many companies wanted you to remember their product and often came up with cute, short jingles. Do you remember any local jingles from the Troy area? Here is a sample to wake up those brain cells.

> *Don't sign your name, it would be a shame,*
> *until you see your Bumstead Man!*

Despite the fact that I was about six years old and limited to driving toy cars when I heard it, that Bumstead tune still stays in my head. Bumstead Chevrolet was on the corner of Fifth Avenue and Congress Street in the '50s and '60s.

Don McClaughlin can sing the old Stanton Brewery jingle:

> *With an S and a T and an A and an N and a T-O-N,*
> *spells Stanton's Beer.*
> *By every rule and every test, you'll find that Stanton is the best.*
> *With an S and a T and an A and an N and a T-O-N,*
> *spells Stanton's Beer.*

Stanton brewed its beer on Fifth Avenue just south of Ferry Street until the 1960s.

Speaking of beer, how about these two jingles on a beer coaster:

> *After a hard day's work, relax. Fitz fits a hero*
> *Been Heroic Lately? Fitz fits a Hero!*

Those are jingles for Old Fitzgerald Brewery, formerly on River Street. I have special feelings toward that brewery. On my eighteenth birthday, I downed four quarts of Fitz and a dozen brownies. Have never been lightheaded since!

Finally, Kathy and Bob Sheehan know the words and melody to one of my favorites:

> *Freddie Freihofer, we think you're swell,*
> *Freddie, we love the stories you tell.*
> *We love your cookies, your bread, and your cakes.*
> *We love everything Freddie Freihofer bakes!*

# What's In a Name? Sounds Greek to Me!

It's all in the timing, as one philosopher said. Nothing could be more true when it comes to how Troy got its name. Troy was still farmland when the War of Independence ended in 1783. The village of Troy was laid out in 1787 from the farmland of Jacob D. Vanderheyden and it was called Vanderheyden in honor of the landowner. It was also known as Ashley's Ferry or Hook, as Vanderheyden's house was used as the place where people could take a ferry across the Hudson River, near present-day Ferry and River Streets. However, on January 5, 1789, the residents of Vanderheyden decided to change the name to Troy. Why? Some think it was because Troy was easier to write. Probably not!

America had just won its freedom from England and there was a great feeling of democratic spirit throughout the country. Why not name their city after Greece, the country and cultural influence that created democracy? Moreover, a few years later, Greece itself was fighting for independence from the Turks (1821–30) and the young America was sympathetic to the cause. Troy was not alone in the adoption of the classics in name and style either. Many other cities in New York State followed suit: Athens, Attica, Ithaca, Ilion, Marathon, Syracuse and Delphi, to name a few. About 1818, this classical influence started showing up in architecture as well and the Greek Revival period (1818–50) is considered the first truly national style in America.

So in honor of these classical roots, let's look at some of the features and buildings of Troy that remind us of our early beginnings.

One of the most famous Greek literary stories of the Trojan War is Homer's *Iliad*. *The Iliad* is about the wrath of Achilles at the actions of Agamemnon, and describes the story of his withdrawal from the war. *The Iliad* was the inspiration for the archaeological work of Heinrich Schliemann, who discovered the site of Troy at Hissarlik, in modern Turkey in 1871. Our city is named after that fabled city, which was rebuilt several times.

The well-known Cummings architectural firm of Troy designed the Ilium Building, on the corner of Fulton and Fourth Streets. Ilium is another name for Troy. There are two geomorphic rises in Troy. Prospect Park, located between Congress and Hill Streets, rises 240 feet above sea level. The peak was named Mount Ida, which is the home of Zeus, the principal god of the Greeks. The other is Mount Olympus, 100 feet above sea level and located between Rensselaer, Vanderheyden, River and Sixth Streets. Actually Fifth Avenue now runs through it. Mount Olympus is the highest peak in Greece and home to all the Greek gods. In 1823, an octagonal building sat on top of our Mount Olympus, serving cordials and beverages until it burned in 1830.

The Lyceum was the name of the school outside Athens where Aristotle taught (335–323 BC). A lyceum is a hall in which public lectures, concerts and similar programs are presented. The Troy Lyceum of Natural History was organized in 1818 and was the first society of its kind. Many of the artifacts they collected were later disbursed to RPI and the Troy Library. St. Peter's Lyceum was located on Hutton and Fifth Avenue. St. Peter's Church created it in 1885 as a social and athletic club.

Apollo Lodge, a Masonic lodge created in Troy on June 16, 1796, was named after the Greek god of music, medicine and poetry.

Apollo Hall was located in a building on the southeast corner of Congress and River Streets. The hall was used by the Troy Turn Verein, a German fraternal society, and organized on August 8, 1852 (reorganized on September 30, 1885). They met on Wednesday evenings in the hall.

The Athenaeum building was located on First Street, between River and State Streets. It was built by the Troy Savings Bank in 1845 and was torn down recently for a parking lot. It was named for Greek goddess Athena.

Greek influence didn't end in the nineteenth century either. During the first quarter of the twentieth century, Greek immigrants found their way to Troy and opened restaurants throughout the city. Two such examples are the Famous Lunch on Congress Street, and Hot Dog Charlie's in the Burgh, both still serving customers.

"The Approach" was a grand entrance to the city from RPI when it was built in 1908 in Greek style. The Ionic columns and lighted staircase were built on the site of the former RPI main campus building, which burned in 1904.

Perhaps the most lasting examples of our fascination with the classics are in the architecture that bears the Greek name. Beginning in the 1820s, American architects were influenced by design books filled with buildings that were loosely based on ancient Greek temples. Probably the best-lasting examples were made in government buildings, but it worked its way right down to the single-family dwelling and Troy has quite a few examples.

One the more interesting examples of Greek Revival architecture is called Cottage Row, a grouping of three small Greek temple–like homes that were built on the east side of Second Street between Liberty and Washington Streets about 1840. Designed with Ionic porticoes (a porch or walkway with a roof, supported by columns) and built by carpenter Norton Sage, this Greek triplet was written up in an 1843 edition of *The Cultivator*, an Albany magazine, and even included an engraving of the homes. Each of the homes was separated from the other by a garden screen. Sage lived in the middle house and sold the other two. Aside from the removal of the garden screens, the replacement of

the columns on one of the homes and the erection of a three-story building between two of them, Cottage Row still exists as it did 159 years ago.

You have seen other examples of these little Greek temples scattered throughout the city. The building at 274 Eighth Street was the 1840 home of Luther McCory, a merchant. Charles Lindley, a clerk at the *Troy Daily Whig* lived at 163 Third Street in 1844. Joseph C. Taylor, a coppersmith, lived at 356 Third Street in 1838. John B. Lull lived at 549 Sixth Avenue (Lansingburgh) about 1840. John Moray lived at 819 Third Avenue (Lansingburgh) about 1845. Daniel Hudson, a tanner and furrier, lived at 358 Third Street about 1844. Many of these homes still exist and stand out from the surrounding homes like, well, a Greek temple.

Perhaps the most impressive example of Greek architecture now belongs to Russell Sage College. The First Presbyterian Church on the southwest corner of Sage Park was built in 1836. It's the oldest church building of this denomination in the city, although it no longer functions in that capacity. It is designed in Greek Doric Order, similar to temples such as the temple of Poseidon at Paestum, and the Parthenon in Athens.

How many of these Greek temples still exist in Troy? You tell me!

## PARK THE BULLDOZERS, PLEASE

Familiarity breeds contempt, as the old proverb goes. A while back I was talking to a couple that lived near the Grand Canyon. I remarked how beautiful it must be to have such a natural wonder as their backyard. Their reply was, "Oh, you mean that hole in the ground!" I'm afraid that attitude has also been pervasive in Troy for the last thirty years. It appears that each time a building of historic significance becomes vacant, it gets torn down, and another "hole" is punched in the historic fabric of Troy.

Certainly some buildings must be razed if they are a hazard to human life. However, the indiscriminate practice of knocking buildings down without any regard to the visual impact of a neighborhood, its historic significance or to potential for reuse has to be reevaluated. These gaping holes that line the streets of Troy give the city a battlefield appearance.

Troy, if anything, has a great human and industrial history, and it has the architecture to prove it. Each building in the city represents a piece of a giant historical puzzle. A row of one-hundred-year-old bank buildings on First Street tells us something about the financial conditions of Troy and its citizenry back then. Workers' housing in South Troy gives us a look into how blue-collar

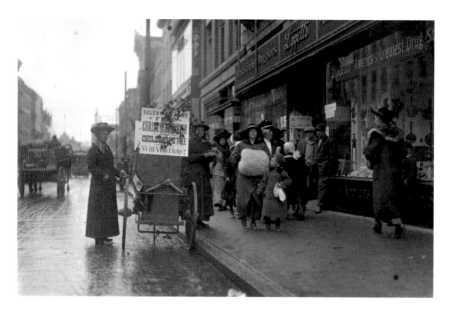

Here is a view down a busy Third Street showing shoppers and a Salvation Army worker about 1915. *Courtesy of Tom Clement.*

families coped and labored in iron foundries or collar and cuff factories. The many large estates on East Side tell us how the owners of those factories lived well from their entrepreneurialism. The landscape of old factories represents industries that played an important role in the early development and growth of this country during the nineteenth century. The hundreds of merchant buildings in downtown each tell a story about the original owner's dream of providing a service or product and trying to make a decent living. The many churches dotted throughout the city show a citizenry rich in religious convictions. All of this weaves a rich historical tapestry of understanding about our city. People like to feel good about where they live. You can't if you don't feel connected.

Just because these buildings may no longer serve their original functions does not mean that they need to be destroyed, wiped from the visual landscape like some painter who doesn't like his or her first brush of artistry. If every building downtown met such criteria, there wouldn't be a building standing. Every building tells a story about the people who built it and worked in it, and a multitude of stories can be told from events that occurred within its walls.

I think part of the reason for this mass destruction of Troy's history is the fact that for years we suffered from a collective low esteem and took out our frustrations on the symbols of that which had left us. It's true that Troy lost many of its industries in the '50s and '60s. The ill-conceived and devastating

urban removal period of the '60s and '70s excised large blocks of Troy's downtown, and forced thousands of people to move out of the city. Only fifty years ago, the city population was almost eighty thousand, twice what it is today. It's not surprising that an attitude of "tear it down and it won't remind us" prevailed. Out of sight, out of mind! After all, vacant buildings without the hum of human toil are constant reminders of a once-prosperous Troy.

During the summer, not too long ago, the Fuller and Warren Stove factory building was demolished in South Troy. When I stopped and asked the crane operator why he was tearing it down, he shrugged and said he didn't know why. He was just following orders. "Stewart" brand cast-iron stoves heated up millions of homes around the world during the nineteenth century. A Stewart stove represented quality and workmanship and the Troy foundry men that made them were proud of their work. We are still tearing buildings down in this city for no reason, but there also is a new trend on the rise.

Jack Hedley proved that a former industrial building, the old Cluett-Peabody factory, could be turned into productive new workspace. He did it again with the old Miller, Hall & Hartwell building near Hoosick. The Hall building was renovated at First and River. The old J.L. Thompson Drug buildings on River Street are in use again. Other similar examples can be seen along the streets of downtown. This is only a beginning of the revival of Troy, but there is still work to be done to stop eradicating our visual pages of history.

An important first step for the city is to create a historic sites commission, whose purpose it will be to inventory Troy's remaining historic infrastructure and determine a priority system for preserving and reusing those surviving historic resources. The city should partner with individuals, agencies and organizations that share the vision that preserving Troy's past is paramount to having a prosperous future. National Grid should agree to supply at low cost, or for free, minimum power to a priority building to heat it so it doesn't fall into disrepair from the elements during winter, a fate of so many vacant buildings.

Before any building in the city is taken down, the commission would review it and the emphasis of the decision should be on preserving and reuse instead of destroying. Furthermore, it should be made clear to any developer coming into our city that they must honor its history and incorporate it into their plans. We do not want Troy to become architecturally homogenized so that a walk down any street will look like *any* street!

Finally the citizens of Troy must accept the fact that Troy will never pour steel for the world again, nor will we be the collar capital of the world. That part of its history is over, though never forgotten. It's time for all Trojans to began building a new Troy, one where we honor and promote the past and at the same time forge

a new future with high technology and brain power in areas such as software development, robotics, education and telecommunications. All of this can be interwoven into the historic fabric of the city. A fiber-optic cable can fit nicely into a 150-year-old row house as easily as it can fit into a brand-new office park. While Troy was the heartbeat of the American Industrial Revolution, there is no reason why it cannot be the nerve center for the communications revolution. It just takes a little vision and resourcefulness. If history teaches us anything, we know that Troy has had both for most of its 200-year-old existence.

Our city was named after the fabled Troy, a city rebuilt several times. Each time the city was destroyed by invaders, its citizens would rebuild from the ruins and remains of the previous city. Our Troy has been here for two hundred years. For more than three-quarters of that time, Troy has prospered economically. Like our namesake, it's time to rebuild from the remains of our past. Preserving Troy's rich historic architecture is the beginning of this journey

## Rumors "Razing" Eyebrows

We all know how rumors fly in this city—quicker than you can say "Uncle Sam." One rumor not long ago was that someone at city hall wanted to see the Brown Building (207–215 Broadway) get razed. A few bricks fell into the alley from a modern carriage house attached to the building and within days, workers were tearing the rest of it down quicker than a politician changing party lines in Troy. Let's try to discourage this since this is a vitally important building on Broadway and all efforts should be attempted to bring the building back into use. Taking it down would create one ugly hole in a street that has been coming back big time in recent months.

The Brown building was built circa 1876, and is named after its builder, Samuel B. Brown of Bennington, Vermont. He acquired the land from Josephus and Margaret Brockway in 1839.

One of the first merchants in the building was Thatcher Clark, who turned lot 215 into a boardinghouse. Several other storefronts were added at 213, 211, 209 and 207 for future tenants and filled quickly. James Hatch, a confectioner and fruit dealer, moved into 213, and R.P. Tunnard, a pharmaceutical retail and dry goods retailer, moved into 211. By 1894, it was well known as a "merchants' stomping grounds," as all five stores were filled, selling everything from hats to candy.

The boardinghouse at 215 became known as the "Clark House," under a new proprietor, Charles Batchelder. At 213, Mrs. M. Brown managed a confectionary store, and 211 had Mrs. S.A. Walker, who was a milliner. William

The Clark House (or Hotel) on the right provided boarding especially during winters like the one in 1898. *Courtesy of Tom Clement.*

Vanderburg, at 209, sold boots and shoes, and at 207, Misses Elizabeth and Sara Skene had a millinery business located there. Many of these people were still in the building at the turn of the twentieth century.

By 1902, the Clark House changed hands to C.C. Sinsabaugh and he renamed it the Victoria Hotel. The following year, George C. Lucas bought it and renamed it back to the Clark House. In 1934, Albert and Alphonse Ramone and Alphonse's wife Bessie opened a restaurant named the Tavern at 209–211; they purchased the entire building in 1936. By 1958, only the Tavern and Clark House were still operating in the building. Starting in 1960, the Troy Chamber of Commerce began to hold their meetings at the Tavern.

The Tavern moved in 1962 with the passing of Alphonse Ramone, but his wife Bessie maintained ownership. By 1967, only the Clark House and Broadway News were operating there. After several ownership changes from 1966, and several attempts to operate new businesses (even the reopening of the Tavern from 1968 to 1979), the building seemed doomed. Even though other uses were attempted, the Clark House and Broadway News continued. Finally, in 1981, the Clark House closed after serving for more than a century. To this day there is a newsstand in the building that has lasted since 1934. The entire length of the building has an ornate cast-iron facade, although only about a quarter of it is showing.

Perhaps the most famous date for the Brown Building is 1938. It has been written that the popular songwriter and pianist Frankie Carle penned "Sunrise Serenade," the number one hit of the time (selling over a million copies), with lyricist Jack Lawrence while working at the hotel. The hotel had a "seedier" reputation then.

The building had been slowly deteriorating until the city stabilized it a few years ago. The former owner paid the taxes and tried to reclaim it but the bank (HSBC) claimed it instead. Someone recently removed the fire escape from the side of the building along with some building wall ties (they hold the beams into place). In recent months, a few people have expressed interest in rehabbing the building; on the night the bricks fell out of the carriage house, the city was going to vote on a proposal but canned it pending the outcome of the falling bricks.

There are a number of ideas floating around for using the building, including apartment and retail space. Saving this building is in the best interests of the city and an all-out effort should be started to make it happen. We have enough gaping holes in our streetscapes—we don't need another one in an area that already has a great deal of restoration going on next door. Fortunately the building has recently been sold to a developer who may bring it back to life.

## SPEAKING IN GRAVE TONES

I have always found it interesting to explore old graveyards and cemeteries over the years. Not only can you learn something about who is buried there, but you can also find a little poetic justice, irony and humor. Epitaphs, inscriptions on stones or monuments that commemorate the person buried there, have always been fascinating because they have been used to honor, vilify and even humor those who are dead for the benefit of the living who read them. They also provide valuable information about an individual's life, social status, family and the time period they lived in. Gravestone art also reflects a change in attitudes toward death, starting from the early fatalistic Puritanical points of view and moving to the more romantic Victorian perspectives. Epitaphs have been found on gravestones as early as Greek and Roman times and earlier Egyptian sarcophagi and coffins.

Many or perhaps most epitaphs are serious, such as this one example from the private Lansing burial ground that was located on a house site in Lansingburgh:

*Erected to the memory of Catherine Lansing Consort of Levinus Lansing*
*Who departed this life March 26, 1822 Aged 70 yrs, 1 mo & 10 days*
*Say what the Mother, wife & friend should be,*
*In this imperfect slab, and that was she.*
*Kind Angels watch her sleeping dust*
*Till Jesus comes to raise the just*
*Then may she wake with sweet surprise*
*And in her Saviours image rise.*

Many people have collected epitaphs that are a bit different and there are a number of books published that feature the funny ones. I offer a few of my favorites.

Here's one from Falkirk, England, dated 1690:

*Here lie the bones of Joseph Jones*
*Who ate while he was able.*
*But once overfed, he dropt down dead*
*And fell beneath the table.*
*When from the tomb, to meet his doom,*
*He arises amidst sinners.*
*Since he must dwell in heaven or hell,*
*Take him—whichever gives the best dinners.*

On the death of Ezekiel Pease from Nantucket, Massachusetts:

*Pease is not here, Only his pod.*
*He shelled out his Peas*
*And went to his God.*

Here's one that stung:

*In Memory of Beza Wood*
*Departed this life Nov. 2, 1837 Aged 45 yrs.*
*Here lies one Wood*
*Enclosed in wood*
*One Wood*
*Within another.*
*The outer wood is very good:*
*We cannot praise the other.*

A firemen's parade passes by city hall about 1913. City hall replaced the old village cemetery and was itself replaced by Barker Park. *Courtesy of Tom Clement.*

How about a little irony from the stone of Ellen Shannon, buried in Girard, Pennsylvania:

*In loving memory of Ellen Shannon, aged 55,*
*Who was fatally burned March 21, 1870*
*by the explosion of a lamp filled with*
*"R.E. Danforth's Non-Explosive Burning Fluid"*

Or how about a couple close to home. From the stone of Harry Edsel Smith of Albany:

*Born 1903—Died 1942*
*Looked up the elevator shaft to see if the car was on the way down.*
*It was.*

And in Vail Cemetery in Schenectady:

*He got a fish-bone in his throat and then he sang an angel note.*

112

Here is some justice for someone buried in Thurmont, Maryland:

*Here lies an Atheist*
*All dressed up*
*And no place to go.*

Only in America could you find the next one. This is from the stone of Elizabeth Rich of Eufala, Alabama:

*Honey you don't know what you did for me,*
*Always playing the lottery.*
*The numbers you picked came in to play,*
*Two days after you passed away.*
*For this, a huge monument I do erect,*
*For now I get a yearly check.*
*How I wish you were alive,*
*For now we are worth 8.5.*

Since I realize that some day I will go the way of those before me, I have been trying to find the perfect epitaph for my own headstone. Here are my top ten selections so far:

*10. So where's the thermostat?*
*9. Now do you believe me?*
*8. Hey, watch where you're standing!*
*7. I may be here, and you are there, but the day will come when this ground we'll share!*
*6. Death isn't what it's cracked up to be!*
*5. I do remember asking for the top bunk!*
*4. I may be stiff, or burned to ashes, but one thing's certain, I don't need glasses.*
*3. At least I won't be getting anymore junk email!*
*2. He saved old buildings, and the Pine Bush past, but the bottom line is he couldn't save his own a\*\*!*

And my number one pick for my headstone (borrowing a bit from W.C. Fields):

*1. All things considered, I'd rather be standing where you are!*

# TROY'S ANCIENT WONDERS

Let's look at some of the ancient wonders of the Capital District, and focus on several of Troy's ancient treasures—both natural and human made.

## Bessemer Steel Works, South Troy

In 1863, Alexander L. Holley purchased the American rights to the Bessemer steel process for Corning, Winslow, & Company of South Troy. It was the same year the Bessemer Steel Works of Winslow, Griswold & Holley was built on the site of the old flourmill of Thomas Witbeck. The company built a two-and-a-half-ton plant south of the mouth of the Wynantskill and on February 16, 1865, the first Bessemer steel in the country was produced. This was instrumental in making America the world's leading iron and steel producer for years. You would never know it existed today.

## Burden Iron Wheel

The Burden iron wheel was built in 1838–39. It was huge! Weighing in at sixty feet in diameter and twenty-two feet in width, it had thirty-six buckets—each six feet three inches deep. With an impressive twelve-hundred-horsepower output, it was called the "Niagara of water wheels." It powered Henry

The first Bessemer steel was made here in Troy. *Courtesy of the Rensselaer County Historical Society.*

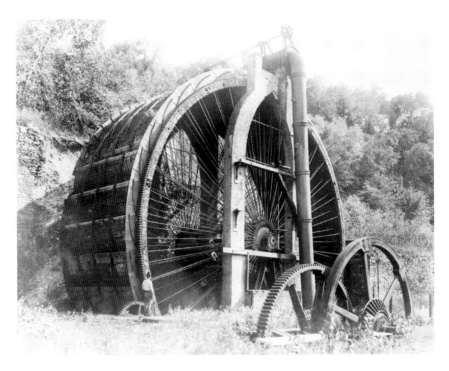

The Burden iron water wheel. The Niagara of water wheels, it produced power for Burden's horseshoe-making machines for years. It was later scrapped for the war effort. *Courtesy of the Library of Congress.*

Burden's upper works along the Wynantskill, helping to produce millions of horseshoes and perhaps other iron products.

This massive industrial tool is credited as the blueprint for a more recreational pursuit, the Ferris wheel, invented by RPI graduate George Ferris. His Ferris wheel debuted at the 1893 World's Columbian Exposition in Paris. Like the Burden wheel, it, too, had thirty-six buckets (seats).

The Burden wheel sat quietly, rusting away for years (and well documented in photographs) until it was dismantled and taken away for scrap during World War II, I am told. All that remains is the pit in which it sat.

## Congress–Ferry Street Tunnel

The block underneath Congress to Ferry Street along Sixth Avenue is a buried train tunnel that once served the Troy Union Railroad Depot, built in 1854. Trains coming into Troy at South Troy would slowly move through the city, crossing Second, Third and Fourth Streets, and enter a smaller tunnel

at Fifth Avenue and Liberty Street. A few feet north, the train reached Ferry Street, moving through the block-long tunnel and exiting on the Congress Street side, finally moving into the station after a few feet more.

You drive over Sixth Avenue every day but what you are really driving over is the old railroad tracks. The Depot stood where the Raddick Building now sits.

I would like to see the entrance to the tunnel brought back and the old steam locomotive owned by the Mohawk & Hudson chapter of the National Railway Historical Society put on the tracks just exiting the tunnel. It would be a great tourist attraction.

## Marshall Power Tunnel

In 1840, Benjamin Marshall dammed up the Poestenkill above Mount Ida Falls to form a reservoir (now called Belden Pond). He then drilled a six-hundred-foot tunnel through the rock on the north side of the falls to create a tunnel in which to funnel water down to power a series of mills built on the hillside, especially his own cotton mill. This power canal was operational until 1962, some 122 years of continuous operation. You could say it still is operational since there is a hydroelectric plant at the site that uses some of the old power canal system.

## Mount Ida Falls

One of Troy's natural wonders, Mount Ida rises over two hundred feet above sea level as the water tumbles down the falls toward the Hudson not far from it. Waterpower from this region was used as early as 1667 when Jan Barentsen Wemp operated a sawmill.

The falls were one of Troy's major tourist attractions during the eighteenth and nineteenth centuries and have been mentioned in many an early traveler's diary. A wooden bridge crossed just in front of the falls and families often had picnics and outings there.

However, to the geologist, it's where the famous rock thrust, first known as the Logan Fault, was discovered. This thrust slope begins in Canada and runs down to Alabama. Here in the gorge you can see older rock deposits of the Cambrian period resting on top of earlier ones of Ordovician age (it's supposed to be the other way around). It's now called the Emmons Thrust, named after Ebenezer Emmons, graduate of RPI's first class and first junior professor.

The falls were the focus of a major restoration project by the Friends of Prospect Park and Mount Ida Preservation Society.

The Ferry Street Train Tunnel is now buried, but at one time it allowed trains to come into the city from the north and south, running between Ferry and Congress Streets for more than a century. *Courtesy of Jim Shaughnessy.*

Greta Wagle stands in the Marshall Tunnel, a power tunnel that supplied water power to several mills in the Poestenkill Gorge. *Courtesy of the author.*

Mount Ida Falls. The falls supplied water power for many mills along the Poestenkill Valley. It was also a place for people to picnic. Here the Logan Fault shows older rocks over younger rocks. *Courtesy of the Library of Congress.*

## Troy Music Hall

Where can you find a room with nearly perfect acoustics without fancy technology? The Troy Music Hall, located inside the Troy Savings Bank, is such a room. It was built in 1875 as a token of appreciation to Troy's citizens. Designed by architect George Browne Post, the hall is 106 feet long, 69 feet wide and 61 feet high, and was dedicated on April 19 by Theodore Thomas with orchestra and vocals. Many a famous artist has performed here over the last 150 years.

The Troy Music Hall was awarded National Historic Landmark status in 1989 and continues to provide first-rate performances.

## Troy's Roller Coaster Days

On the east side of Fifth Avenue, between 108th and 110th Streets, and running east to the foot of Oakwood Cemetery, is a tranquil, nicely kept residential area of Lansingburgh.

But on this same spot eighty years ago, you would have heard the cries of midway barkers, the thunder of running horses, the laughter of children and the roar of a roller coaster.

This forty-two-acre parcel of land was one of the finest amusement parks in the country and was known as Rensselaer Park. Its tag line was: "The Real Pleasure Ground for the Pleasure Bound."

Rensselaer Park had a half-mile racetrack and Midway amusement area tucked away within a huge, beautiful grove of trees. Today, it survives only in memories and a few photographs.

The entrance to Rensselaer Park was on Fifth Avenue, just north of 108th Street (108th Street did not extend east of Fifth). The park was organized in 1867 as the Rensselaer Park Association, but originally was a training ground for Union soldiers and was called Camp Willard during the Civil War. An army hospital was also established there. The buildings were used as a hospital for a cholera epidemic and later as a slaughterhouse complex. It also housed the Rensselaer County Fair for years.

The park closed in 1917 and the land was sold in 1919, eventually turning into the residential neighborhood you see there now.

One of the big draws of the park was the carousel called the Menagerie. For a quarter, you could ride hand-carved horses, bears, giraffes, camels, lions, elephants and goats. After the park closed, the carousel ended up in Halfmoon Beach. Eventually it was sold along with the individual animals.

Among the many other amusements was a small ten-seat Ferris wheel. The world's first Ferris wheel, 264 feet high, debuted at the 1893 World's Colombian Exposition in Paris. The exposition also had the first Midway, called the Midway Plaisance (or White City Midway). Its well-lit and fancy building facades dictated how amusement parks would be designed for the following sixty years.

It was difficult to get bored at Rensselaer Park. There was a bowling alley, a high wire act, pony rides, a figure-eight wooden roller coaster, a dancing pavilion, a skating rink and a band shell where concerts were held every afternoon and evening. Fireworks were held every Thursday night.

For only a dime, you could view Bama the Ostrich Girl, step up to the Hindu Theater, watch wild animals get tamed, become awestruck as a man or J.W. Groman's High Diving Horses leaped from a tower into a lake that was located within the southern portion of the racetrack. The one-and-a-half-mile

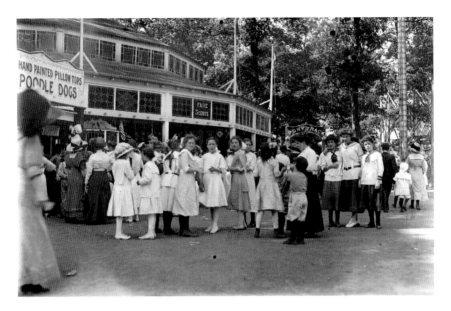

Kids getting ready to go on the carousel at Rensselaer Park in Lansingburgh. *Courtesy of the author.*

racetrack, fully visible in all directions, filled the eastern part of the park in sharp contrast to the densely wooded Midway section. Complete with a grandstand and judges' tower, people lined up on the northern part of the track to watch harness, bicycle and even chariot races.

The park had its own police squad to direct traffic and handle the mobs of people that frequented the park.

The Haymakers, a local baseball team that became the foundation for the New York Giants, played here during the park's first year. In 1868, the same year that the racetrack, secondary road (around the track) and pond were built, the team drew five to nine thousand people at one game. The park trustees built them a U-shaped bleacher somewhere near the track.

One strange incident occurred at the park and was reported in the papers. A cannibal with one of the shows bit a Lansingburgh resident and the local newspapers proclaimed that the man would probably die as a result of the bite. The cannibal escaped, but I can't find out what happened to the victim.

While amusement parks got their start in the United States in the nineteenth century, they go way back to medieval Europe and were known then as pleasure gardens. Areas were set aside and created specifically for outdoor entertainment and amusement. These first parks included fountains and flower gardens, but also included games, bowling, music, dancing, shows and a few

primitive amusement rides. In 1583, an amusement park opened in Bakken, north of Copenhagen. It is still in operation today.

By 1919, at the end of Rensselaer Park's life, there were over fifteen hundred amusement parks still in operation in the United States. By 1935, after the stock market crash, the number dwindled to only four hundred. The only remaining establishment that could be considered an "amusement" park locally is Hoffman's Playland in Latham, built in 1952 with fourteen "kiddie" rides and five major rides that adults can use. Yes, I still go there.

# TROY'S HOLY CORNERS

You don't have to be religious to appreciate the architecture of churches and synagogues, particularly those built in the nineteenth century. As individual landmarks, they're works of art, often containing within their structures artifacts such as Tiffany windows or locally made Meneely bells. A church often stands out as the tallest structure in a neighborhood—on one hand letting us know that it's there if we need it, and on the other offering a reminder that those tall spires or bell towers are just a bit closer to heaven than we are.

At the turn of the century, Troy had over seventy churches, almost one church for every one thousand people living in the city. There are about half of that today and many are falling down from disrepair and lack of support, like the Fifth Avenue Baptist Church did recently. Troy is still a city of faith but it's hard to maintain those buildings without a population to support them.

Troy got its first church when Jacob D. Vanderheyden gave the newly formed Presbyterian Congregation three building lots on the south side of Congress Street fronting on First Street (now Sage Park). On the middle lot in 1792 a plain wooden meetinghouse was built.

Other denominations followed: Baptists, Methodists, Quakers, Protestants, Lutherans, Universalists, Catholics and Jewish, all building houses of worship throughout the city.

Most people think of religious institutions only as places of worship, but they served other important functions during Troy's industrial age. Most of Troy's population was working twelve to fifteen hours a day, six days a week. Religious institutions offered a social net (support services) to an upper- and working-class population as well as the indigent.

Church schools were an early benefit brought to Trojans. While they certainly ensured a good dose of religious training in many, the basic ABCs were taught; even degrees of higher learning were offered in some.

St. Paul's Parish School was started in 1808 on the north side of the public market on the northwest corner of Third and State. The Society of Friends (Quakers) in 1823 built a schoolhouse on the corner of State and Fourth (State Street side), just down the street from St. Paul's. The School of Industry of St. Paul's was an outgrowth of the Mary Warren Free Institute that started in 1815. This school taught poor girls how to sew and make their own clothes and later taught vocals. The Troy Episcopal Institute in 1838 helped young men prepare for college. The short-lived Troy University, organized by Methodists, provided degrees in agriculture and civil engineering. La Salle Institute was organized in 1847 for Catholic boys. Many parochial schools were created in the nineteenth century and still exist today.

The Troy Hospital (St. Mary's) was founded by Catholic priest Peter Havermans as a result of dealing with destitute and sick Irish immigrants in 1848. Another hospital, St. Joseph's Maternity, was located in the remodeled home of the Sisters of St. Joseph on Jackson and Fourth Streets as late as 1923.

Havermans also founded St. Mary's Female Orphan Asylum (later St. Vincent's Female Orphan Asylum) in 1848, run by the Sisters of Charity, and the Troy Catholic Male Orphan Asylum in 1850.

In 1854, the Church Home of the City of Troy was formed by the Brotherhood of St. Barnabus as a house of mercy in a house at 5 Harrison Place and later Federal Street. This Episcopal-run home charged $300 for elderly ladies who wanted to become residents. A Presbyterian home for the aged was formed in 1871 on Fourth Street (where Proctor's Theater is now). The Little Sisters of the Poor established a home for the indigent in 1875 on Hutton Street.

Mount Magdalen School of Industry and Reformatory of the Good Shepherd was founded for wayward girls in 1884 by the Religious order of the Good Shepherd. The reformatory was on Peoples Avenue, part of which is now used as RPI's Incubator. This same order ran the Guardian Angel Home and Industrial School next door.

Homeless infants were cared for by the St. Joseph's Infant Home, created in 1898 at Thompson and Mill Streets. Working girls were housed by the Seton Home for Working Girls, which was housed in the old Jacob Vanderheyden home north of Hoosick Street. It was run by the Sisters of Charity.

Even social clubs were created, such as St. Peter's Lyceum in 1885, and St. Joseph's Club in 1892.

To me there is no holier land than the southwest corner of Fourth and State Streets. In 1806, the Troy Quakers rented and later bought a small house there for services. In 1874, the First Unitarian Church bought the property and built a large church. It was sold to St. Anthony's Roman Catholic Church in 1905,

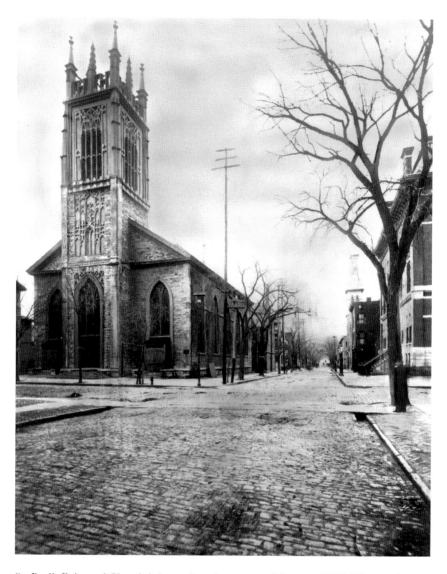

St. Paul's Episcopal Church is located on the corner of State and Third Streets. Several Tiffany windows light up from the sun in this church. City hall is on the right. The daughter of the pastor of this church is responsible for *Troy Sentinel* publishing Clement Moore's now-classic "'Twas the Night before Christmas" in its December 23, 1823 edition.

which continues to own the site—that's 193 years of religious ownership, more than 90 percent of the time Troy has existed.

I remember attending first grade in the original St Anthony's school, an old two-story Victorian house on Fifth Avenue across from the Stanton Brewery. In 1956, a new brick school was built next to the church on Fourth Street. Actor/comedian Jimmy Durante, a friend of Father Thomas DeLuca, attended the opening and dedication ceremonies.

The Sisters who taught at St. Anthony's had no problem keeping discipline. They carried rulers and map pointers and knew how to use them. I had my share of visits to Sister Superior's office, but for a young Catholic boy, the corner of State and Fourth was an important intersection, not only for automobiles, but also for learning moral values.

My cousin David and I, both altar boys versed in Latin, served Mass in the large brick church that used to stand on the corner. On a Sunday afternoon, hundreds of parishioners would mingle after Mass and chat. Sometimes the school had events and once a year a bazaar was held at which one could win prizes and eat ethnic food. It was a busy corner.

Today, the corner of Fourth and State is a parking lot with a steel-link fence surrounding the church's rectory. It looks more like a fortified compound under siege, but then perhaps it is symbolic—many churches are fighting to survive.

There is a solution. I would suggest to all the leaders of the various religious denominations in Troy that they get together and agree that on the first Sunday of each month, all Masses or services will not be religious, but will feature a public discussion on what can be done to help each other, or will meet to preach about values or the need for community building. (If you don't think we need this, say the word "Columbine" three times.)

The non-religious meetings would allow the residents of Troy, no matter what faith they are, to spend each of those Sundays visiting a different church or synagogue, admiring its architecture and artifacts, meeting people and networking and making a financial donation that will help support the survival of these architectural landmarks.

I can think of at least one person who probably thinks it's a great idea.

## WHATEVER HAPPENED TO PRESIDENT PARK?

In 1845, a city map showed the entire city block bounded by Madison, Monroe, Second and First Streets laid out and labeled as President Park. Rows of single-family house lots faced all along the perimeter of the park.

It's not surprising that this park would be named "President." Most of the east–west running streets that comprise South Troy were named after previous U.S. presidents: Washington, Adams, Jefferson, Madison, Monroe, Jackson, Van Buren, Harrison, Tyler and Polk.

Situated almost in the middle of South Troy, President Park no doubt was designed to accommodate a projected rise in housing and influx of Trojans—21,709 lived here in 1845, and the number almost doubled fifteen years later.

Perhaps it was symbolic of an attitude that working people needed open space too. After all, the smaller but very private Washington Park laid out in 1840 was located just four blocks north of it. However, there does not seem to be much of a history associated with President Park and today it doesn't even exist. Maybe it never did!

Unfortunately, the knowledge of whether this park was ever officially opened or used has evaded my research so far. In 1929, Rutherford Hayner made a passing comment about it, and not a very flattering one either.

Troy's open space or parks movement began early with the founding of the village. On May 10, 1796, Jacob D. Vanderheyden gave to the village of Troy three lots for use as a public square that today comprise present-day Sage Park on Congress between First and Second Streets.

However, since the Burgh was annexed to the city in 1900, the earliest park now on record is the village green that Jacob A. Lansing donated to the village of Lansingburgh on July 4, 1793. It's located at 112th Street.

These two plots were not parks as we think of them today, since Vanderheyden also allowed the "erecting of a public schoolhouse or academy if judged proper by the inhabitants." Likewise, the original Lansingburgh Academy was built on the village green in the Burgh.

It would take more than eighty years before a dedicated park system was developed in the city. Prior to that, citizens would utilize public cemeteries like Oakwood (created in 1848) or private groves for picnics and outings.

In 1879, Troy citizen John Sherry, called the father of Troy's park system, offered the city about 5 acres east of Fifteenth Street between Peoples and Jacob Streets for use as a park. More acres were donated by two other citizens, increasing the park to 6.28 acres. By 1914, the city had laid out walks, lawns, flowers, a fountain, a soldier's monument, bathrooms and a children's playground.

A drinking fountain (for both horses and humans) was erected on the corner, unique by present standards. Horses drank from the roadside while humans drank from the sidewalk. It still exists, although someone has planted flowers in both basins!

Troy's first "public" park was named Beman Park after the Reverend Dr. Nathan S.S. Beman, who was the pastor of the First Presbyterian Church for about forty years.

In 1890, a Troy Citizen's Association was created and headed by Walter P. Warren, president of the famous Warren and Fuller Stove Company of South Troy. The association passed a resolution calling for a public park near the city waterworks off of Oakwood Avenue. Two years later, the city created a park commission that had a mandate to preserve the waterworks property for a park, as the citizen group had requested. It wasn't until 1922 that the legislature allowed the city to use the property, however.

Members of the William H. Frear family had already donated 22 acres of land back in 1917 to add to the park (eventually bearing his name). An additional 22 acres were donated by Jennie Vanderheyden in 1923, and another parcel by the Eddy estate, culminating in the present-day 150-acre Frear Park.

In 1891, the sons of Deborah Powers, a prominent business family in the Burgh, donated a little more than two acres as a memorial park to their mother and father. The park is the block between 2nd and 3rd Streets and 110th and 111th Streets.

Troy's most elegant park, Prospect Park, sits atop Mount Ida overlooking the city, and was created in 1903 after the city purchased it from the Warren family. The park was laid out beautifully by city engineer Garnet D. Baltimore, the first African American to graduate from RPI. Prospect Park had winding roads, outlooks with towers that permitted a view twenty-one miles up the Hudson River Valley, fountains, playgrounds and flower gardens.

The former residences of the Warren family were converted into a museum and casino. One old-timer told me he use to get ice cream cones in one of them.

The last major parkland was donated by John Knickerbocker in 1924. He purchased much of the former Rensselaer Amusement Park between 103rd and 108th Streets in the Burgh.

Beman, Frear, Prospect and Knickerbocker Parks are still in use, though they are not as popular as in past times. All have suffered from various forms of neglect over the years.

A "Friends of Prospect Park" organization is attempting to rejuvenate this once-popular spot. Most baby boomers will remember the days at the Prospect pool, or at least getting thrown out of it. Often, kids would sneak in at night and take a dip.

I remember picking up large horse chestnuts from the chestnut trees by the pool, putting them on strings and having battles with my friends. Of course, you can't find a chestnut tree anymore since they were hit with the blight.

During the summer, the Troy Boys Club took us to the park for swimming and playing. We used to walk up the "backside" (the steep slope) path that started on Seventh Street by Uncle Sam's house.

The land where President Park was situated now has homes and businesses on it. There isn't a trace of use as parkland and the history of this "park" still remains an enigma.

For its size, Troy has almost three hundred acres of parks for a population of nearly fifty-thousand residents. It seems to me that if RPI's Approach can be restored, so can Prospect Park. Perhaps what we need is a Prospect Park Day to reintroduce the park to its citizens, with performances, cookouts, artworks, contests, nature walks and one huge fireworks display.